Secrets of
ACRYLIC
LANDSCAPES START TO FINISH

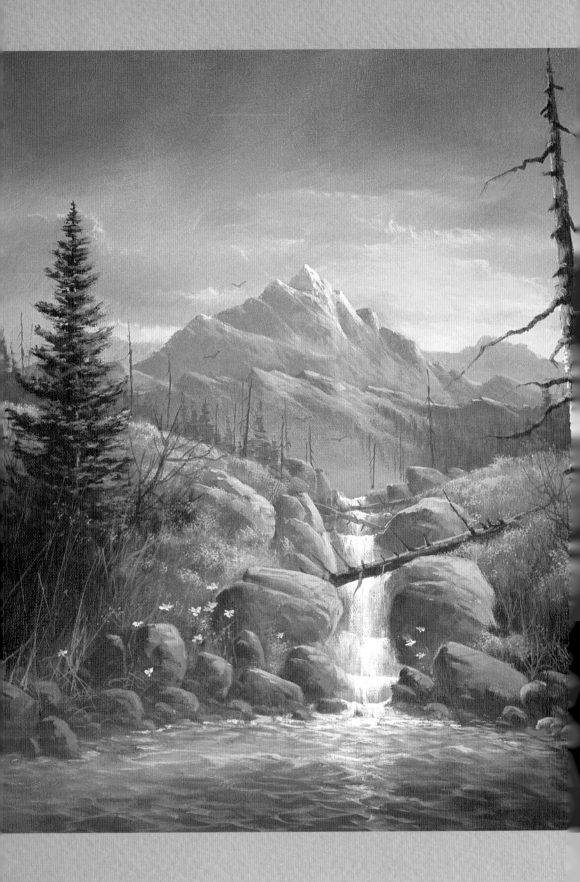

Secrets of
ACRYLIC
LANDSCAPES START TO FINISH

Jerry Yarnell

NORTH LIGHT BOOKS

DEDICATION

It was not difficult to know to whom to dedicate this book. I give God all the praise and glory for my success. He blessed me with the gift of painting and the ability to share this gift with people around the world. He has blessed me with a new life after a very close brush with death. I am here today and able to share all of this with each of you because we have a kind, loving and gracious God. Thank you, God, for all you have done.

Also to my wonderful wife, Joan, who has now gone on to be with the Lord. I know she must have loved me or she would not have endured the hardships of an artist life and stuck with me all those years.

Lastly, to my two sons, Justin and Joshua: You both are a true joy in my life.

ACKNOWLEDGMENTS

So many people deserve recognition. First, I want to thank the thousands of students and viewers of my television show for their faithful support over the years. Their numerous requests for instructional materials are really what initiated the process of producing these books. I want to acknowledge my wonderful staff, Diane, Scott and my mother and father for their hard work and dedication. In addition, I want to recognize the North Light Books staff for their belief in my abilities.

Peaceful Waters
12" × 16" (30cm × 41cm)

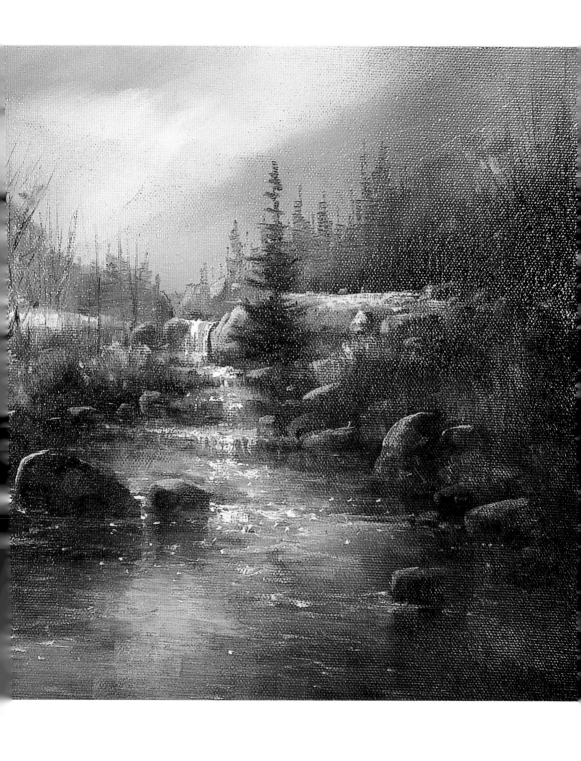

CONTENTS

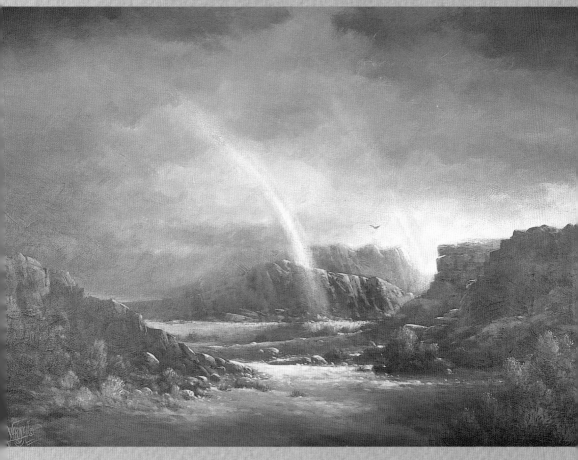

End of the Rainbow
24" × 30" (61cm × 72cm)

INTRODUCTION

Hopefully by now you have had a chance to become familiar with the basic techniques of landscape painting through my previous books. Until now, we have only scratched the surface. Keep in mind that painting requires a lifetime of learning, practice, patience and experimenting. In this book, we will explore the many different areas of landscape painting that often create problems for most beginning and intermediate artists.

Over the years I have realized—for myself and my students—that sometimes the best way to learn new techniques, subjects and styles is to do a series of what we call thumbnail studies or paintings. Thumbnail paintings are small practice segments of a painting you may be struggling with; thumbnails are done on scrap canvases. Maybe you're painting a landscape with a beautiful sunset, or a snow-capped mountain, or a waterfall with large boulders, and you're really struggling with the rocks in the waterfall or the water running over the rocks. Or maybe you just can't quite get the snow-capped mountain right. Well, I've discovered that by setting your painting aside, getting a scrap of canvas and working out your problems on that scrap instead of on the original canvas, you will have a tendency to learn faster. You will be less concerned about messing up on the thumbnail-study painting than you would working on the original. Artists generally are more relaxed and not as afraid to experiment with different techniques, color schemes and applications when they're working with smaller segments on a canvas board. Once you work out everything on the thumbnail, you'll have much more confidence to try the techniques on the original without as much fear of messing up your beautiful painting.

In this book we will primarily focus on thumbnail paintings to learn specific subjects, techniques, color schemes and more. I know you'll love this way of learning. It will be exciting, fun, and very informative. So grab your paints, brushes and some scraps of canvas or canvas boards and let's get started.

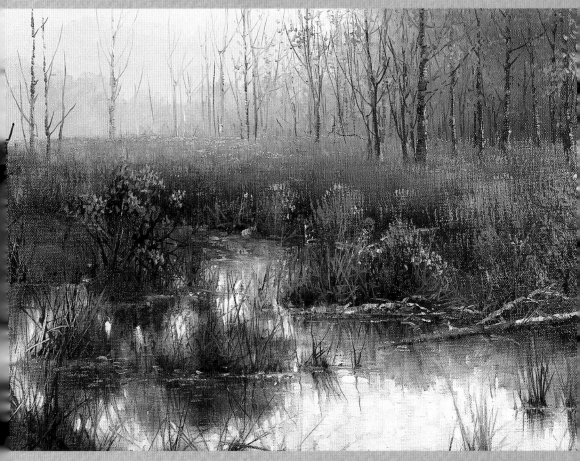

Peace Be Still
12" × 16" (30cm × 41cm)

Terms and Techniques

COLOR COMPLEMENTS

Complementary colors are always opposite each other on the color wheel. Complements are used to create color balance in your paintings. It takes practice to understand the use of complements, but a good rule of thumb is to remember that whatever predominant color you have in your painting, use its complement or a form of its complement to highlight, accent or gray that color.

For example, if your painting has a lot of green in it, use its complement—red—or a form of red, such as orange, red-orange or yellow-orange. If you have a lot of blue in your painting, use blue's complement—orange—or a form of orange, such as yellow-orange or red-orange. The complement to yellow is purple or a form of purple. Keep a color wheel handy until you have memorized the color complements.

CREAMY

In most of my books, you hear me use the word "creamy" in every study. For the acrylic technique, I teach the principle that the paint has to be very creamy for it to work correctly. In other words, when a mixture needs to be creamy, it should be like the consistency of soft butter.

DABBING

This technique is used to create leaves, ground cover, flowers, etc. Take a bristle brush and dab it on your table or palette to spread out the ends of the bristles like a fan. Then load the brush with an appropriate color and gently dab on that color to create the desired effect.

DOUBLE LOAD

Often it is necessary to put two colors on your brush to create a mottled effect, create special blends in a sky, or underpaint certain things like large, grassy areas, tree trunks, rock formations, etc. To double load, simply put one color on one corner of the brush and another color on the other corner of the brush. Then blend them together on the canvas itself.

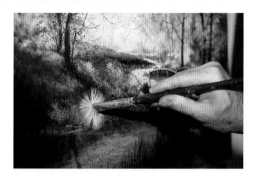

To prepare your bristle brush for dabbing, spread out the end of the bristles like a fan.

DRYBRUSH

This term is often misunderstood. There are two aspects to drybrushing: loading and applying. To drybrush, take whatever mixture you are using and, after loading a very small amount on your brush, wipe some of it onto a paper towel or another surface. Once the brush is properly loaded, very lightly skim across the surface of the subject you are painting with very light pressure. Thus you have created a drybrush effect.

EYE FLOW

Eye flow is the movement of the viewer's eye through the arrangement of objects on your canvas or the use of negative space around or within an object. Your eye must move or flow smoothly throughout your painting or around an object. You don't want your eyes to bounce or jump from place to place. When you have a good understanding of the basic components of composition (design, negative space, "eye stoppers," overlap, etc.), your paintings will naturally have good eye flow.

FEATHERING

Feathering is a blending process used to soften the edges of certain objects. You take the color and carefully blend it in whichever direction you need until the color fades into the background and there are no visible edges where the colors are blended together. This is

sometimes hard to do. It usually requires a dry-brush technique.

GESSO

The reason I put gesso on this list is because many of my students from around the world ask the question, "Why do you use gesso instead of white paint?" The answer is simple: Gesso is very opaque, and acrylic white paint is more transparent. For years, artists have been complaining about their acrylic paintings looking too "plastic." I used to complain, too. However, I discovered that because gesso is opaque (especially the thick gesso I use), mixing with acrylic takes away the plastic look. Gesso also softens colors, is much easier to blend and is great for creating texture. I have actually had judges at art shows think my acrylic paintings look like oil paintings because of my use of gesso, which adds more body to the paint. Be sure you use the thick, heavy-bodied gesso.

GLAZE (WASH)

A glaze or a *wash* is a very thin layer of paint applied on top of a dry area of the painting to create mist, fog, haze, sun rays or to soften an area that is too bright. This mixture is made up of a small amount of color diluted with water. It may be applied in layers to achieve the desired effect. Each layer must dry before you apply the next.

INKY

Inky is a term I use whenever I need to use the no. 4 sable script liner brush. This script brush will work properly only if the paint you are using is very thin. I like to compare this to an artist's ink called India ink, which is a black ink artists use to fill their sketch pens and calligraphy pens. It's very fluid. So when you create an inky mixture, be sure it has a similar consistency to that of India ink.

MOTTLED

Mottled means nothing more than applying several different colors at the same time in an unorganized fashion. This results in no distinct changes of color but rather various subtle changes of values and colors. Mottling works great for skies and all types of underpainting.

NEGATIVE SPACE

This is the area of space surrounding an object that defines its form.

Here is an example of poor use of negative space. Notice the limbs do not overlap but are evenly spaced instead. There are a few pockets of interesting space.

Here is an example of good use of negative space. Notice the overlap of the limbs and the interesting pockets of space around each limb.

SCRUBBING

Scrubbing is simply a term that describes a technique for applying paint to your canvas. Scrubbing is typically used for underpainting and any other areas that don't need to be as refined or feathered. Scrubbing is more of a rough application of painting. Normally you will use bristle brushes to scrub because they can take the punishment this technique creates on a brush. Take the paint and use any and all parts of the brush to apply the paint in certain areas where a much rougher finish is acceptable. Use different pressures and be much more aggressive when scrubbing.

SCUMBLE

Scumbling is a bit like mottling. To scumble, use a series of unorganized, overlapping strokes in different directions to create effects such as clumps of foliage, clouds, hair, grass, etc. The direction of the stroke is not important for this technique.

SIX-FOOT VIEWING DISTANCE

I thought it would be a good idea to discuss the six-foot-viewing-distance rule. Over the years, I've noticed that when many students start painting, they spend most of their time painting while standing only a few inches from the canvas. The reality is that when you stand too close for too long, your eye will not focus properly and you will generally make more mistakes. You can see some things properly only from a distance, especially things like perspective and proportional issues. You may have heard the old saying "You are too close to the forest to see the trees." This applies perfectly for artists. When you're painting, stand back about six feet every few minutes, not every hour. This allows your eyes to focus properly so you can make any necessary adjustments. The six-foot viewing distance is the main reason most fine art brushes have long handles—the long handles keep you at more of a distance. So try to get into the good habit of standing back frequently. I'm sure you will see a huge difference in the quality of your work.

UNDERPAINTING OR BLOCKING IN

These two terms mean the same thing. The first step in all paintings is to block in, or underpaint, the darker values of the entire painting. Then you begin applying the next values of color to create the form of each object.

VALUE

Value is the relative lightness or darkness of a color. To achieve depth or distance, use lighter values in the background and darker values as you come closer to the foreground. Raise the value of a color by adding white. To lower the value of a color, add black, brown or the color's complement.

You can change the value of a color by adding white.

Getting Started

ACRYLIC PAINT

The most common criticism about acrylics is that they dry too fast. Acrylics do dry very quickly through evaporation. To solve this problem, I use a wet palette system, which is explained later in this chapter. I also use very specific dry-brush blending techniques to make blending very easy. If you follow the techniques I use in this book, with a little practice you can overcome any of the drying problems acrylics seem to pose.

Speaking as a professional artist, acrylics are ideally suited for exhibiting and shipping. An acrylic painting can actually be framed and ready to ship thirty minutes after it's finished. You can apply varnish over acrylic paint or leave it unvarnished because the paint is self-sealing. Acrylics are also very versatile because the paint can be applied thick or creamy, to resemble oil paint, or thinned with water for watercolor techniques. The best news of all is that acrylics are nontoxic and have very little odor, and few people have allergic reactions to them.

USING A LIMITED PALETTE

As you'll discover in this book, I work from a limited palette. Whether for my professional pieces or for instructional purposes, I've learned that a limited palette of the proper colors can be the most effective tool for painting. This palette works well for two main reasons: First, it teaches you to mix a wide range of shades and values of color, which every artist must be able to do; second, a limited palette eliminates the need to purchase dozens of different colors. As we know, paint is becoming very expensive.

So, with a few basic colors and a little knowledge of color theory, you can paint anything you desire. This particular palette is versatile, so that with a basic understanding of the color wheel, the complementary color system and values, you can mix thousands of colors for every type of painting.

For example, you can mix Phthalo Yellow-Green, Alizarin Crimson and a touch of white to create a beautiful basic flesh tone. These same three colors can be used in combination with other colors to create earth tones for landscape paintings. You can make black by mixing Ultramarine Blue with equal amounts of Dioxazine Purple and Burnt Sienna or Burnt Umber. The list goes on and on; you'll see the sky is truly the limit.

Most paint companies make three grades of paints: economy, student and professional. The professional grades are more expensive but much more effective to work with. The main idea is to buy what you can afford, and have fun.

Materials List

PALETTE		MISCELLANEOUS ITEMS
White gesso	Titanium White	no. 13 Conté pencil
Grumbacher, Liquitex or	Ultramarine Blue	easel
Winsor & Newton paints		paper towels or rags
(color names may vary):	BRUSHES	palette knife
Alizarin Crimson	2-inch (51mm) hake	no. 2 soft vine charcoal
Burnt Sienna	no. 4 flat sable	spray bottle
Burnt Umber	no. 4 round sable	Sta-Wet Palette
Cadmium Orange	no. 4 script liner	stiff toothbrush
Cadmium Red Light	no. 4 bristle	16" × 20" (41cm × 51cm)
Cadmium Yellow Light	no. 6 bristle	stretched canvas
Dioxazine Purple	no. 10 bristle	water can
Hooker's Green		
Phthalo Yellow-Green		
(or Brilliant Yellow-Green)		

BRUSHES

My selection of a limited number of specific brushes was chosen for the same reasons as the limited palette: versatility and economics.

2-Inch (51mm) Hake

The hake (pronounced ha-KAY) brush is a large brush used for blending. It's primarily used in wet-on-wet techniques for painting skies and large bodies of water. It's often used for glazing as well.

No. 4 Flat Sable

Sable brushes are used for more refined blending, detailing and highlighting techniques. They work great for final details and are a must for painting people and detailing birds or animals. They're more fragile and expensive, so treat them with extra care.

No. 4 Round Sable

Like the no. 4 flat sable brush, this brush is used for detailing, highlighting, people, birds, animals, etc. The main difference is that the sharp point allows you to have more control over areas on which a flat brush will not work or is too wide. This is a great brush for finishing a painting.

No. 4 Script Liner

This brush is my favorite. It's used for the very fine details and narrow line work that can't be accomplished with any other brush. For example, use this brush for tree limbs, wire and weeds—and especially for your signature. The main thing to remember is to use it with a much thinner mixture of paint. Roll the brush in an inklike mixture until a fine point is formed.

No. 10 Bristle

This brush is used for underpainting large areas—mountains, rocks, ground or grass—as well as dabbing on tree leaves and other foliage. This brush also works great for scumbling and scrubbing techniques. The stiff bristles are very durable, so you can be fairly rough on them.

No. 6 Bristle

A cousin to the no. 10 bristle brush, this brush is used for many of the same techniques and procedures. The no. 6 bristle brush is more versatile because you can use it for smaller areas, intermediate details, highlights and some details on larger objects. The nos. 6 and 10 bristle brushes are the brushes you will use the most.

No. 4 Bristle

The no. 4 bristle brush is a cousin to the no. 6 bristle. The reason I have added it to the collection is because as you do more advanced techniques, this brush—because of its smaller size—allows you to have more control during the refinement process of your painting.

With this basic set of brushes, you can paint any subject.

BRUSH-CLEANING TIPS

Remember that acrylics dry through evaporation. As soon as you finish painting, use good brush soap and warm water to thoroughly clean your brushes. Lay your brushes flat to dry. If you allow paint to dry in your brushes or your clothes, it's very difficult to get it out.

I use denatured alcohol to soften dried paint. Soaking the brush in the alcohol for about thirty minutes and then washing it with soap and water usually gets the dried paint out.

THE PALETTE

Keeping the paints wet is critical. There are several palettes on the market designed to help keep your paints wet. The two I use extensively are Sta-Wet palettes made by Masterson. The first palette is a 12" × 16" (30cm × 41cm) plastic palette-saver box with an airtight lid. This palette comes with a sponge you saturate with water and lay in the bottom of the box. Then you soak the special palette paper and lay it on the sponge. Place your paints around the edge and you're ready to go. Use your spray bottle occasionally to mist your paints, and they will stay wet all day long. When you're finished painting, attach the lid, and your paint will stay wet for days.

My favorite palette is the same 12" × 16" (30cm × 41cm) palette box, I don't use the sponge or palette paper. Instead I place a piece of double-strength glass in the bottom of the palette. I fold paper towels into long strips (into fourths), saturate them with water and lay them on the outer edge of the glass. I place my paints on the paper towel. They will stay wet for days. I occasionally mist them to keep the towels wet.

If you leave your paints in a sealed palette for several days without opening it, certain colors, such as green and Burnt Umber, will mildew. Just replace the color or add a few drops of chlorine bleach to the water in the palette to help prevent the mildew.

To clean the glass palette, allow it to sit for about thirty seconds in water, or spray the glass with your spray bottle. Scrape off the old paint with a single-edge razor blade. Either palette is great. I prefer the glass palette because I don't have to change the palette paper.

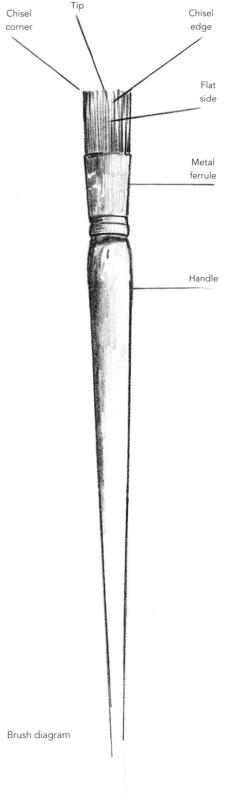

Chisel corner

Tip

Chisel edge

Flat side

Metal ferrule

Handle

Brush diagram

Setting Up Your Palette

Here are two different ways to set up your palette.

PALETTE 1

The Sta-Wet 12" × 16" (30cm × 41cm) plastic palette-saver box comes with a large sponge, special palette paper and an airtight lid.

Saturate the sponge with water. Lay the sponge inside the palette box.

Next, soak the special palette paper and lay it on the sponge. Place your paints around the edge. Don't forget to mist your paints to keep them wet.

When closing the palette-saver box, make sure the lid is on securely. When the palette is properly sealed, your paints will stay wet for days.

PALETTE 2

Instead of using the sponge or palette paper, another way to set up your palette box is to use a piece of double-strength glass in the bottom of the palette. Fold paper towels in long strips and saturate them with water to hold your paint.

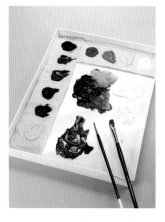

Lay the saturated paper towels on the outer edges of the glass.

Place your paints on the paper towel. I place my paints on the palette in this order: Titanium White or Gesso, Cadmium Yellow Light, Cadmium Orange, Cadmium Red Light, Hooker's Green, Burnt Sienna, Burnt Umber, Ultramarine Blue, Dioxazine Purple, Brilliant Yellow Green, Alizarin Crimson

Use the center of the palette for mixing paints. Occasionally mist the paper towels to keep them wet.

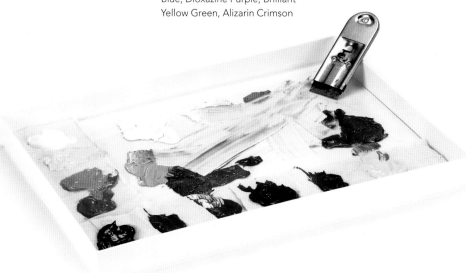

To clean the palette, allow it to sit for thirty seconds in water, or spray the glass with a spray bottle. Scrape off the old paint with a single-edge razor blade.

CANVAS

There are many types of canvas available. Canvas boards are fine for practicing your strokes, as are canvas paper pads for doing studies or for testing paints and brush techniques. The best surface to work on is a primed, prestretched cotton canvas with a medium texture, which can be found at most art stores. As you become more advanced in your skills, you may want to learn to stretch your own canvas. I do this as often as I can, but for now a 16" × 20" (41cm × 51cm) prestretched cotton canvas is all you need for the paintings in this book.

EASEL

I prefer to work on a sturdy standing easel. There are many easels on the market, but my favorite is the Stanrite 500 aluminum easel. It's lightweight, sturdy and easy to fold up to take on location or to workshops.

LIGHTING

Of course, the best light is natural north light, but most of us don't have this light available in our work areas. The next best light is 4' or 8' (1.2m or 2.4m) fluorescent lights hung directly over your easel. Place one cool bulb and one warm bulb in the fixture; this best simulates natural light.

16" × 20" (41cm × 51cm) stretched canvas

SPRAY BOTTLE

I use a spray bottle with a fine mist to lightly mist my paints and brushes throughout the painting process. The best ones are plant misters or spray bottles from a beauty supply store. It's important to keep one handy.

SOFT VINE CHARCOAL

I prefer to use soft vine charcoal for most of my sketching; it's very easy to work with and shows up well. It's also easy to remove or change by wiping it off with a damp paper towel.

CONTÉ PENCIL

Usually when we do sketching for these paintings, we use a no. 2 soft vine charcoal because it is easy to work with, easy to remove and shows up on most surfaces. However, there are times when the area you are working on may be very dark, and the charcoal may not show up. So sometimes I like to use a Conté pencil. It's a soft, white, French pastel pencil, and it must be a no. 13. This shows up well on dark areas and is easily removed with a damp paper towel.

PALETTE KNIFE

I do not do a lot of palette-knife painting; I mostly use a knife for mixing. A trowel-shaped knife is more comfortable and easier to use than a flat knife.

1. Spray bottle
2. Soft vine charcoal
3. Palette knife
4. Conté pencil

A WORD ABOUT MAHLSTICKS AND THE STEDI REST SYSTEM

All of us at one time or another will have days when we are not as steady as we would like to be. Perhaps you're working on something that requires a lot of close-up detail work, or your painting is still wet and you can't steady your hand on the canvas while painting. The solution to these problems is called a mahlstick. I use it, along with a little gadget called a Stedi-Rest.

These photos show the use of a mahlstick both with and without the Stedi-Rest. Either way, a mahlstick is a *must* for most painters. Really, a mahlstick is nothing more than a dowel rod about 36" (91cm) long that can be purchased from any hardware store. The Stedi-Rest must be purchased from an art store. The mahlsticks I stock are handmade from special woods and finishes.

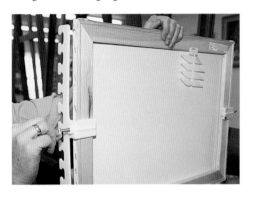

Attaching the Stedi-Rest is a simple matter of screwing the bracket onto the side of your stretcher strip.

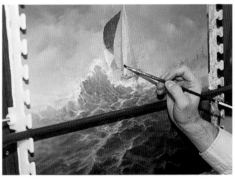

Placing a Stedi-Rest on each side of the painting will allow you to work in several different horizontal positions.

Using your mahlstick on only one side of the Stedi-Rest allows you to work from several different angles.

The mahlstick can be used without the Stedi-Rest by placing it at the top of the canvas to give you more vertical positions.

Understanding Complements

By the time you begin studying these books, you may have had some experience with the color wheel. However, I've noticed that many students still don't have a clear understanding of complements, the value system and graying colors. I would like to spend a little time discussing these issues as they pertain to landscapes. Note: There's much more in-depth study of the color wheel in my technique book.

Most landscape painters use a color wheel of grayed complements. As you probably know, a standard color wheel is made up of three primary colors (red, yellow, blue), three secondary colors (green, violet, orange) and six (intermediate) tertiary colors (red-orange, yellow-orange, yellow-green, blue-green, blue-violet, red-violet). In their pure forms, these colors are too bright to do a traditional landscape. Most artists create their own version of a grayed

color wheel. For my color wheel, I use Hooker's Green, Cadmium Red Light and Cadmium Yellow Light as my primary colors, and mix the secondary and intermediate colors from these. Often we need to gray the colors to achieve the desired effect. We gray a color by adding its complement or a form of its complement.

For example, suppose you want to use Hooker's Green, but it looks too intense for a particular area of your painting. Simply add some of its complement, which is found on the opposite side of the color wheel. You could add touches of Cadmium Red Light, Cadmium Orange, red-violet, red-orange, yellow-orange, etc. These are all forms of complements to Hooker's Green. Use this process for all the colors. To gray purple, add yellows or forms of yellow. To gray orange, add blue or forms of blue, and so on around the wheel.

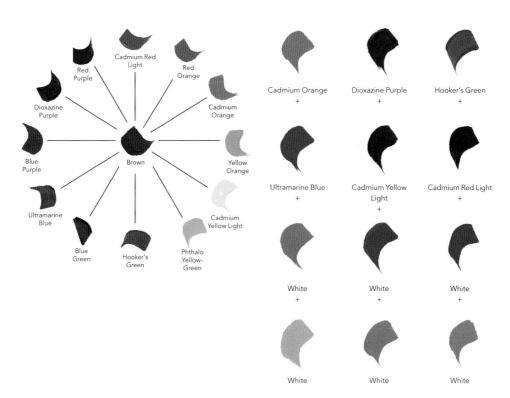

Clumps of Grass

In many landscape paintings, there are times when you need to have clumps of grass and brush to help with the composition and create fillers to finish the middle and foreground areas of the painting. The problem, however, arises when you paint the clumps in perfect rows and evenly space them apart. This can cause your eye to bounce around the painting instead of gracefully flowing through it, and the unnaturally placed clumps may compete with the main center of interest.

1. Underpaint Ground (Dirt)
First, create a mixture of one part Burnt Sienna + one part Burnt Umber + about one-fourth part white; then add a little touch of Cadmium Yellow Light. Take your no. 10 bristle and scrub this color mixture on the area where the grass clumps will be placed. Use short, choppy, vertical strokes to create a slight suggestion of rough dirt.

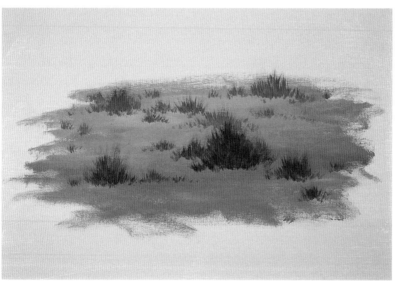

2. Underpaint Clumps
Create a mixture of one part Hooker's Green + one part Burnt Sienna + one-fourth part Dioxazine Purple. Make the mixture very creamy and then load a small amount on the end of a no. 6 bristle. Locate where you want to place a clump. Then, starting at the base of the clump, use a short, vertical stroke and pull upward to create a soft, grasslike effect. This is something you should probably practice on a scrap of canvas until you get the hang of it. Remember to check the placement of each clump so you create interesting pockets of negative space with good eye flow.

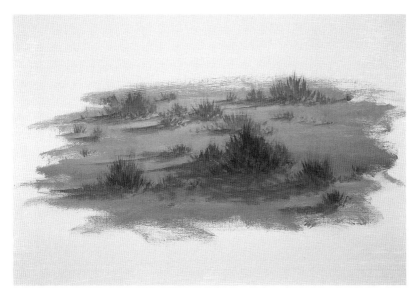

3. Paint Shadows

For the shadows, mix one part Burnt Sienna + about one-fourth part Dioxazine Purple + a touch of white to create a softer value. Take your no. 4 bristle and scrub in the cast shadows on the left side of each clump, following the contour of the ground. You may need to thin the mixture with water a little bit so it will smudge a little easier on the canvas. Let dry.

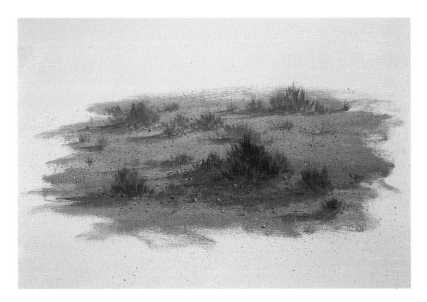

4. Add Pebbles and Small Rocks

This is a really fun step. You will need a fairly stiff toothbrush. Create two or three very fluid, inky mixtures of your favorite light colors (for instance, white with a touch of Cadmium Yellow Light, Orange, or Red Light). Load the toothbrush fairly heavily with the mixtures and then rub your forefinger across the bristles, spattering these lighter colors all over the ground. If you happen to overspatter on the clumps, take a damp paper towel and wipe off the splatter. Do the same thing with some darker colors. This will give you a very "pebbled" look.

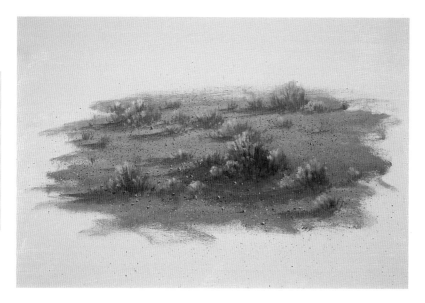

5. Highlight Clumps of Grass

Create a very creamy mixture of Phthalo Yellow-Green + a slight touch of Cadmium Orange. Use your no. 6 bristle to dab this color on the topside of each of the clumps of grass. This creates a nice variety of three-dimensional clumps. Be very careful not to overhighlight; use a very light touch as you dab the highlights onto the clumps.

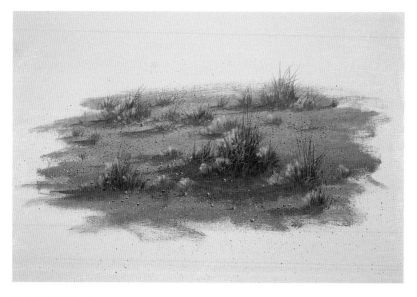

6. Add Tall Weeds

Make a mixture of one part Hooker's Green + one-fourth part Dioxazine Purple. Make this mixture very inky by adding a lot of water. Take your no. 4 script liner and roll it around in the mixture until it forms a nice, sharp point. Add the taller weeds throughout the clumps of grass. Be sure you create taller weeds and shorter weeds, in addition to over-lapping them to make the clumps look more interesting. You also can do this with light colors if you desire.

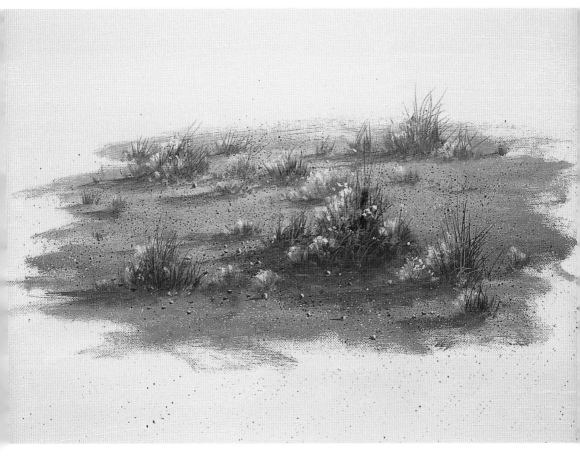

7. Add Flowers and Final Details

There isn't much to this step. It's mostly a matter of adding a few very bright, simple flowers. Do this by taking your favorite colors and adding a little touch of gesso to make each color opaque. Make the mixture very creamy. Take your no. 4 bristle and dab little touches of these colors throughout the clumps of grass. You can add more weeds if you need to and even a few more pebbles or small rocks. Just be careful to add all these final details in moderation.

Weathered Wood and Wildflowers

This is a great study; you're going to have a lot of fun with this one. It may be a little challenging, but it's not as difficult as it looks. The technique for creating weathered wood is primarily a dry-brush technique, and it can be used to re-create many surfaces. This study is primarily focused on an old picket-fence post, but this technique works well for old buildings, tree bark, wooden porches or old wooden tabletops and wooden floors. Get ready to have a great time!

 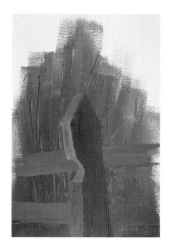

1. Underpaint Background

First, create a mixture of Hooker's Green + a little bit of Burnt Sienna + a little bit of Dioxazine Purple. Use water to thin it down to the consistency of a very thick, creamy soup or chowder. With your hake brush, paint the background using long, sweeping vertical strokes. You want the background to be a little sloppy. While this is still wet, clean the hake and form a chisel edge on its tip by running the hairs of the brush between two of your fingers. (This will also remove any excess water.) Turn the brush vertically to the canvas and lift off some of the background color to suggest distant, taller weeds.

2. Create Basic Sketch

Use a white Conté pencil to roughly sketch the fence. In most rough sketches of general landscapes, you don't need to be too accurate. However, in this case you will want to be very accurate, so make sure you're happy with your sketch before you go on to the next step.

3. Underpaint Fence

Create a mixture of one part Ultramarine Blue + one-fourth part Burnt Sienna + a small amount of white. This should be a medium dark gray. If you want this gray to be a little on the warm side, add a little more Burnt Sienna, if necessary. Take a little bit of this base gray and lighten the value by adding enough white to create a value about three shades lighter than the original.

Take your no. 4 or no. 6 bristle and block in the front of the post with the dark-value gray. Block in the rest of the fence with the lighter-value gray.

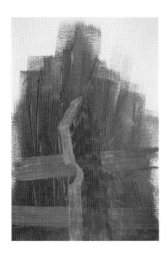 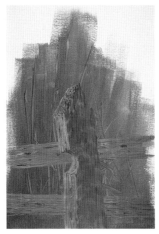 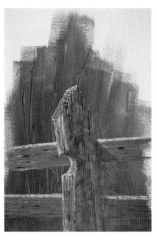

4. Paint Wood Grain

This is a fascinating step. You need a fairly new no. 4 bristle that has a nice straight chisel edge. Lighten the lighter-value gray by adding more white. Thin it to a very creamy mixture and evenly load a very small amount across the tip of the brush. Wipe off a little of it with a paper towel so it's a little drier.

Carefully and lightly drag the brush across the surface of the fence, creating the suggestion of wood grain. This takes practice, so you may have to redo this a few times. You will probably have to experiment with different degrees of moisture to create different effects

5. Paint Knotholes and Cracks

For this step, create a very dark mixture of one part Ultramarine Blue + one-fourth part Burnt Sienna + a little dab of Dioxazine Purple. Thin this down to a creamy, almost inklike consistency. Take your no. 4 script liner and paint in a few dark knotholes. You can now make the mixture very inky and roll your brush in the mixture until it forms a point. With this, paint in some of the cracks and miscellaneous wood-grain lines.

6. Highlight Fence

You'll want to do some minor highlighting to give the fence a little more life and a three-dimensional form. Create a mixture of white with a touch of Cadmium Orange. Use your no. 4 round sable to paint in the top of the back rails to give them dimension. Take your brush and drybrush a few scattered highlights throughout the post and rails. Be very careful not to overhighlight, as you want to only accent the rails and post.

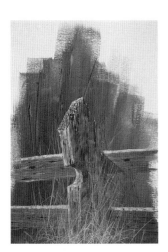

7. Paint the Weeds

Mix about three different light values of yellows and greens (these color recipes are up to you). Be sure to add a little white to the mixtures to make them opaque. Thin them down to a very inky consistency. Take your no. 4 script liner and paint a large variety of weeds. Be sure some of them are very tall and overlap each other. Also, be sure some are behind the fence post and rails.

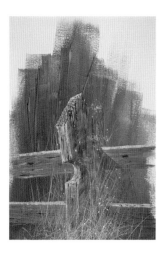

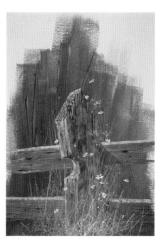

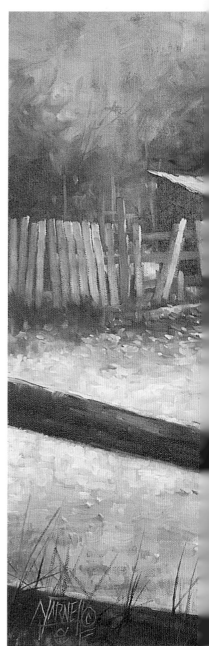

8. Paint Flowers: Phase 1

These flowers are very simple to paint. First, take three or four of your favorite bright colors. For example, you can take Cadmium Red Light, which is a good complement to the green weeds, and then maybe Cadmium Orange, Cadmium Yellow Light, or even white. Make these mixtures very creamy. Load the very tip of your no. 4 flat bristle with each of these colors. Dab on suggestions of flowers throughout the area around the fence, creating a nice balance of color and composition. Use different parts of the brush and pressures to create a variety of shapes.

9. Paint Flowers: Phase 2

This step simply adds the white daisies. I normally create a dull, grayish white. By mixing white with a very slight touch of Ultramarine Blue and Burnt Sienna, you will actually be making a tint. Make the tint creamy and use your no. 4 round sable to paint in the petals, forming the basic shape of the flower. Put a dab of pure Cadmium Orange right in the center of the flower.

Take pure Titanium White and highlight the right side of the flower petals. This gives the flower a bit more form. Take a little touch of Burnt Umber and paint a small shadow on the right side of the orange center to give it a little more of a three-dimensional look.

The important thing about these flowers is that you place them close to the center post and try to give them slightly different angles and groupings to create good eye flow.

Note: You may, at this point, want to add more highlights to the post and rails and, perhaps, add a few more cracks. Be sure to paint the cast shadow from the post onto the rails. Notice that the shadow is at an angle.

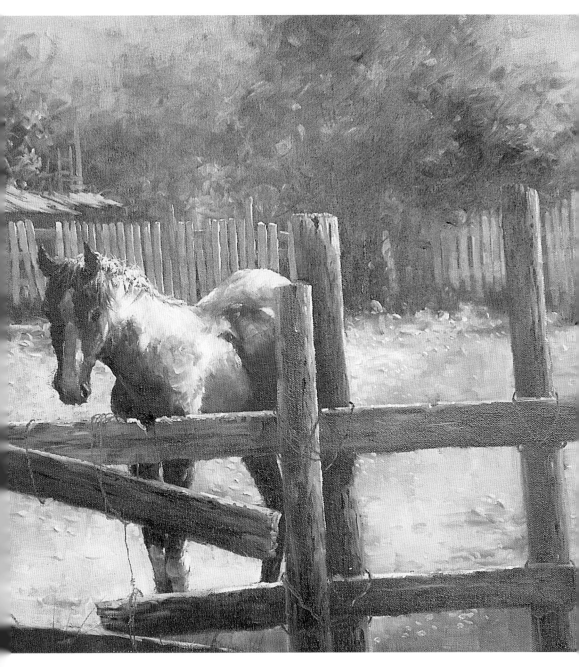

Apply the Lesson
As I mentioned in the study, the technique for creating weathered wood has many applications. In this finished painting, titled *Indian Pony*, you can see where I used this technique. The weathered wood added much more interest to the old rounded fence posts and also to the flat, horizontal braces.

Indian Pony
18" × 24" (46cm × 61cm)

Small Pebbles and Dirt

This is one of the more fascinating studies you will see in this book. Not only is it interesting and artistic, but you can make it literally look photographic if you choose. I have noticed that many artists struggle with creating sand, dirt, pebbles, etc. However, with the technique I'm going to show you here, you will see it is really not that difficult to create very realistic pebbles and dirt that can add great interest to a landscape painting. Grab your toothbrush and let's make pebbles!

1. Underpaint Ground (Dirt)

Start with a medium-dark underpainting. Create a mixture of one part Burnt Sienna + one-half part Burnt Umber + one-eighth part Dioxazine Purple. Block in the underpainting with a no. 10 bristle using broad, horizontal strokes. If the canvas doesn't cover well, let it dry and repeat the step.

2. Highlight Dirt

Create a lighter area through the middle of the background. Add a little white and a touch of Cadmium Orange to the original underpainting color until the value is about two shades lighter than the original. With the no. 10 bristle, scrub this color across the middle area, gradually fading it out from the middle upward and from the middle downward.

3. Spatter Dirt: Phase 1

For this step, you need a fairly stiff toothbrush. Mix a couple of light values: white + a touch of Cadmium Yellow Light, and white + a touch of Cadmium Orange. Mix a couple of dark colors: one part Dioxazine Purple + one part Burnt Sienna, or even a pile of plain Burnt Umber. Make each mixture very soupy, then load the toothbrush.

Rub your forefinger across the brush. This creates little round pebbles. You can adjust the size of your pebbles by how fluid or dry your color mixture is. The size also will change depending on how heavily you load the toothbrush and by how far away from the canvas you hold the brush.

It's a good idea to practice this on a scrap of canvas until you get the hang of it. Use this process for each shadow and highlight color.

4. Underpaint Larger Pebbles and Shadows

To add pebbles that are too large for the toothbrush, create a mixture of one part Burnt Sienna + one part Dioxazine Purple. Then dab on a variety of these larger pebbles with a no. 4 round sable. At the same time, smudge a shadow on the left side of each of the larger pebbles.

5. Highlight Pebbles

For the highlight, mix white + a touch of Cadmium Orange. Use a no. 4 round sable to paint the highlight on the top-right side of each pebble. Depending on the color scheme of your painting, you can change the highlight to almost anything you want.

6. Spatter Dirt: Phase 2

This step is designed to add multiple colors of pebbles to the dirt. In an effort to create color harmony, depending upon the overall color scheme of the painting, you can use Ultramarine Blue, Hooker's Green, Cadmium Red, Dioxazine Purple or any color you want. Just be sure to add a little bit of gesso to each color to make it more opaque. Repeat the process used in step 3 and you will see the dirt really come alive.

7. Add Final Highlights on Pebbles

Remember that acrylics have a tendency to dry darker, so the original highlight color you used in step 5 may have dried less bright than you intended. If this is the case, rehighlight each of the larger pebbles with the same highlight color you used before.

Stone Pathway

Sometimes a winding pathway entering into a painting can be the key to creating a great composition, especially if the pathway is made out of stone. However, most student artists have trouble making the stones appear as if they are lying flat, which obviously is the secret to making the pathway as a whole appear flat. To draw and paint a flat stone, you must create an *ellipse*—a round object that takes on an oval shape depending upon the angle at which you view it. My main goal here is to help you see how to make the pathway appear to be lying flat.

1. Create Basic Sketch
With soft vine charcoal draw a very rough sketch of the shape of the pathway and the ground formation around the pathway. Keep it simple—it will change, anyway, as you begin to paint.

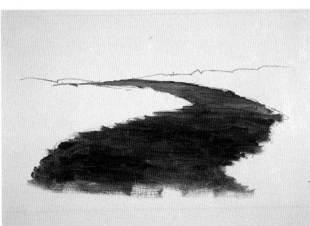

2. Underpaint Pathway
Create a dark mixture of one part Burnt Sienna + one part Burnt Umber + about one-eighth part Dioxazine Purple. Take either a no. 6 or no. 10 bristle and paint on the color using short, choppy, horizontal strokes. Don't be afraid to add additional touches of Burnt Sienna, Burnt Umber or even a little white here and there to create minor color and value changes. Be sure the canvas is well covered.

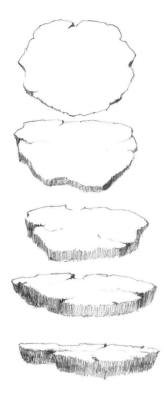

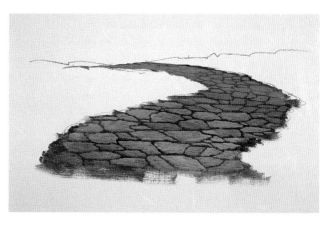

3. Underpaint Stones

Now that you have an idea of what an ellipse is, you may want to use a white Conté pencil to sketch in the shape of all your rocks before you start painting. Otherwise, you can shape them with your brush as you begin to paint.

The stone color is made up of the original underpainting color + little bit of white and a little bit of Cadmium Orange. This creates a value that is about two to three values lighter than the underpainting. I normally use a no. 4 flat bristle to paint the stones, but you can use a no. 4 flat sable if you wish.

Thin the mixture to a very creamy consistency and then simply fill in the shape of each rock. Keep in mind that the stones are smaller in the background and become larger as you move toward the front of the pathway. Be sure to leave a thin space between each stone.

Understanding Ellipses

Before we go on, make sure you have a complete understanding of what an ellipse is and how to use one in a painting. The illustration at left shows the evolution of an ellipse. The top is a full view of a stone standing on its edge. As you begin to lay the stone down (at more of an angle), it appears to become flatter. This flattened circle is an ellipse.

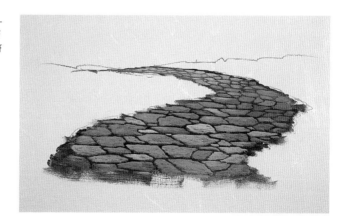

4. Highlight Stones

To create better color harmony, use a variety of colors when highlighting the stones. The best way to accomplish this is to start with a base highlight color made of white + a slight touch of Cadmium Orange. Then you can add any color you want to the base. A touch of Hooker's Green, Ultramarine Blue, Cadmium Red Light, Cadmium Yellow Light, etc. can be used here. Thin each of these colors to a very creamy consistency. Load a small amount on your no. 4 flat sable and begin highlighting each stone with whichever highlight color you choose. There is no particular order, but don't overhighlight.

35

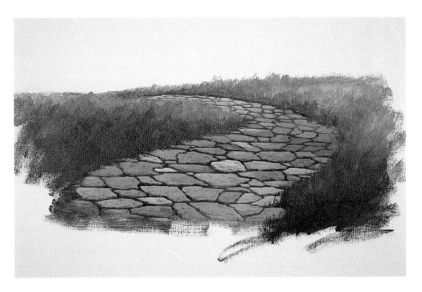

5. Underpaint Grass

To settle the stones into the landscape, scrub in some grass on both sides of the pathway. Mix Phthalo Yellow-Green with a little Hooker's Green and use your no. 10 bristle. Scrub the light areas in the background by pushing upward, creating a grassy texture. As you come forward, begin adding more Hooker's Green and touches of Burnt Sienna and Dioxazine Purple until the foreground grass is very dark.

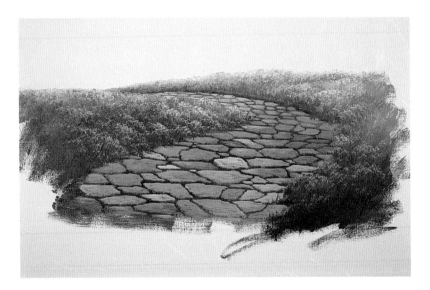

6. Highlight Grass

Create a very creamy mixture of one part Phthalo Yellow-Green + a small touch of Hooker's Green and, if you like, a bit of Cadmium Yellow Light and/or a bit of Cadmium Orange. Load the very tip of a no. 6 or no. 10 bristle and dab the highlight color on the grass, leaving very interesting pockets of negative space. This helps create contour to the ground formations. Don't be afraid to experiment with various colors and values.

7. Add Shadows and Highlights

Add a little white to the original highlight colors used in step 4. Then, with a no. 4 bristle or no. 4 flat sable, highlight the stones mostly on the left side of the pathway and towards the back.

Mix up a shadow color of Burnt Sienna + a touch of Dioxazine Purple, making it very creamy. Take your no. 4 bristle and scrub in the cast shadow on the right side of the road making sure you gradually fade the shadow out towards the center of the road.

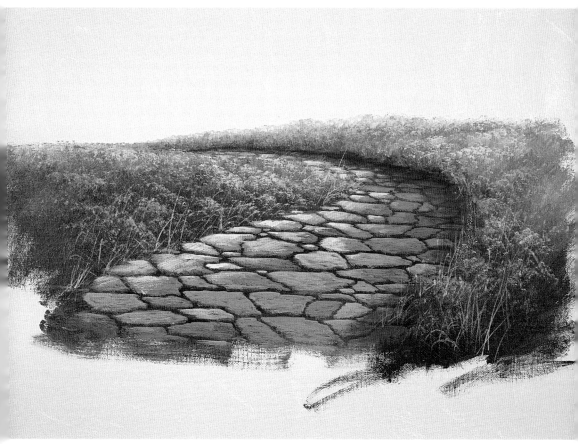

8. Add Final Details

At this stage, have fun highlighting the grasses by using your favorite flower color and dabbing some suggested flower shapes throughout the grassy areas. Then, use your no. 4 script liner to create some inky mixtures of light- and dark-value greens and paint in some taller weeds.

Rocks

I love to paint rocks, but after many years of teaching, I've discovered that most students struggle with this subject. Rocks are very common in many landscapes and can add unique interest to a composition. While there are many different kinds of rocks, the basic concept used to paint them remains the same, so don't be afraid.

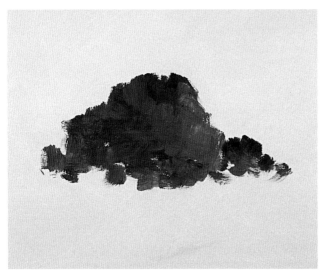

1. Underpaint Rocks
You won't need to premix any color here because you will be doing all your mixing on the canvas. Start by double or triple loading your no. 6 bristle brush with Burnt Sienna, Ultramarine Blue and a little Dioxazine Purple. Scumble all these colors together in a mottled fashion. Add small touches of white as you go to create various middle-tone values. Don't overblend, or everything will become one color or value. You want to leave brushstrokes and some texture.

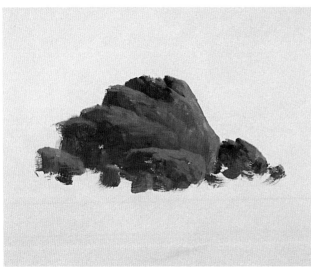

2. Highlight Rocks: Phase 1
This first highlight is made by adding a little white and a touch of Cadmium Orange to the underpainting color created in step 1. This should create a shade about two values lighter than the underpainting. Make the mixture very creamy and load a small amount on a no. 4 bristle. Because the light source is from the right side, carefully scrub this highlight on the top-right side of the rock formation. Leave interesting pockets of negative space. Be sure to leave some of the background showing through so the rocks will have good three-dimensional forms.

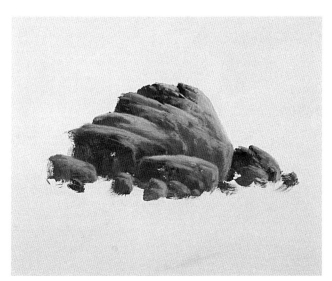

3. Highlight Rocks: Phase 2
Add a little more white and a little more Cadmium Orange to your highlight color to create a value about three values brighter than in step 2. Make this color very creamy and load a small amount on your no. 4 bristle. Re-highlight everything you highlighted in step 2.

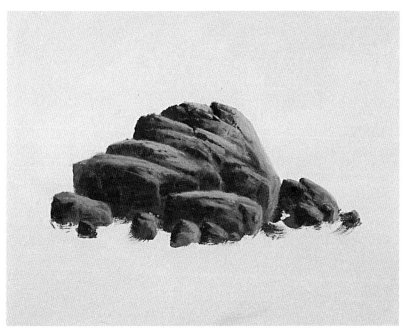

4. Form Shadows
By now, there's a good chance that you may have overhighlighted or painted out too much negative space. This step will help you reestablish any negative space you may have lost. Take some of the underpainting color from step 1 and use a no. 4 bristle to paint back in some of the darker areas that you may have lost. This is a good time to restructure any rock you need to change.

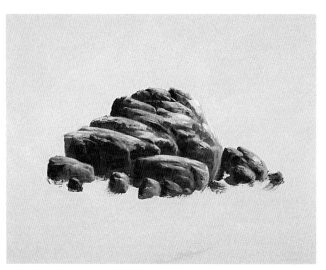

5. Highlight Rocks: Phase 3

Switch to a no. 4 flat sable. Create a mixture of white with a slight touch of Cadmium Orange and Cadmium Yellow Light. This should be a nice, bright highlight color. It's important that this mixture is very creamy. Load a very small amount on your brush and carefully rehighlight the highlighted areas. Use short, choppy strokes to help create a little texture. Once again, be careful not to overhighlight. If you do, go back to step 4 and add a few more dark areas of shadows.

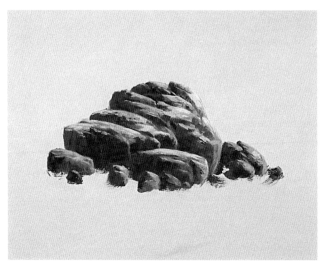

6. Add Reflected Highlights

This step gives the rocks a more three-dimensional shape. Reflected highlights are used on any object that needs to look more rounded.

Mix one part white + one part Ultramarine Blue + about one-fourth part Dioxazine Purple. Load a small amount of color on a no. 4 flat sable and carefully paint the back side of the rock formations. Carefully blend the color across until it fades into the shadow. This is very easy to overdo, so be careful not to use too much paint.

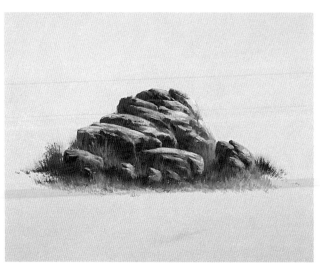

7. Add Grass at Base of Rocks

This step simply makes the rocks appear more settled in the landscape. Double load a no. 6 bristle with Phthalo Yellow-Green and a little bit of Hooker's Green. Start at the base of the rock formations and pull up some clumps of grass to various heights. Do not be afraid to add more color and adjust the values to create more dark and light areas.

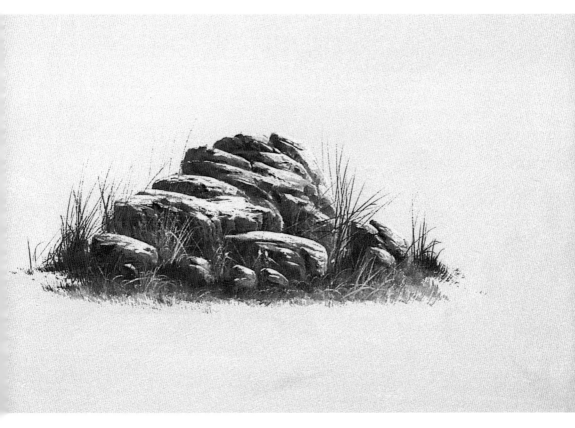

8. Add Final Details and Highlights

Add some taller weeds and a few brighter highlights on the rocks. You also could add a few cracks and crevices to create more detail. For taller weeds, create very inky mixtures of a light color and a dark color and then use your no. 4 script liner to paint them in.

For the final brighter highlights on the rocks, use white with a touch of Cadmium Yellow Light or a touch of Cadmium Orange or both. Then use a no. 4 flat sable to apply the highlight on the very top edges of the rocks. If you need to add a few darker cracks, use the original underpainting value you used in step 1.

Eroded Banks

Erosion may be a real problem for some land-owners, but it can be a great inspiration to an artist. If handled correctly, eroded banks and dirt cliffs can be a wonderful compositional asset to any painting. Banks and cliffs are not easy; their shape is rough and irregular, but they must flow gracefully and naturally into the rest of the landscape. I'll show you how to create these great land formations so they become an asset to your painting—not an eyesore.

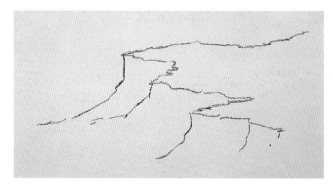

1. Create Basic Sketch
Draw a very rough sketch of the banks' simple shape. The banks will change some when you paint them, so don't spend too much time trying to make them perfect.

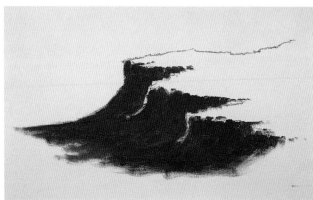

2. Underpaint Banks
Create a warm, dark mixture of one part Burnt Sienna + one-fourth part Dioxazine Purple + one-fourth part Burnt Umber. Block in the shape of the banks with a no. 6 bristle using long comma strokes. As you reach the bottoms of the banks, make your strokes more choppy and horizontal. Be sure the canvas is well covered.

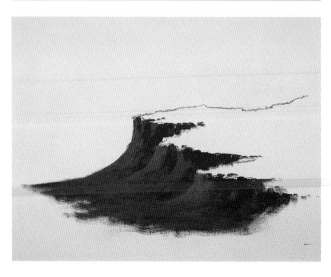

3. Highlight Banks: Phase 1
Mix one part Burnt Sienna + one-fourth part Cadmium Yellow Light + about one-eighth part white. This should create a soft, warm tan. Make the mixture very creamy. Pick up the color with a no. 4 bristle and highlight the edges of the banks with short, choppy strokes. This particular highlight should not be too bright; its only purpose is to help create the form of each of the banks, so don't overload your brush. You may also need to thin the mixture a bit more so some of the background will show through the highlights.

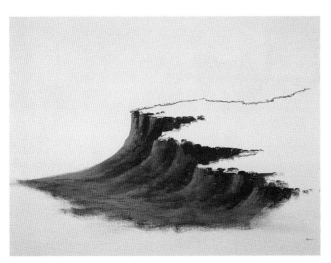

4. Highlight Banks: Phase 2

Add a touch of Cadmium Orange to white to create a great highlight color. Make this mixture creamy and highlight the banks again, using short, choppy strokes. Allow some of the background to come through to create the illusion of rough dirt. Do not over highlight! If you do, take some of the original under-painting color and paint out that section. Then start the highlight process over, using a no. 4 bristle.

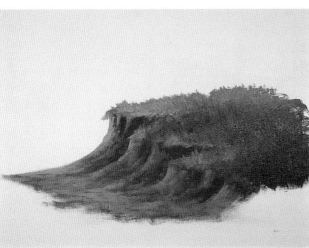

5. Underpaint Grass

Pick up Hooker's Green with touches of Burnt Sienna and Dioxazine Purple and scrub across the top of the banks. Add a little Phthalo Yellow-Green (or Brilliant Yellow-Green) and scumble all these colors together. While this is still wet, take a no. 10 bristle and, with the bristles flat against the canvas, begin pushing upward, starting at the back of the grass area and gradually come forward. When you get to the edges of the banks, pull the grass over the edges. This will help tie the banks and grass together.

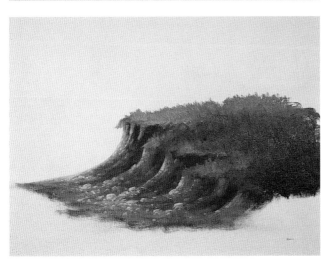

6. Detail Banks

Use the highlight color from step 4 (white + a touch of Cadmium Orange) and a no. 4 flat sable to paint in small pebbles along the base of the banks. You can put some of these pebbles against the sides of the banks, but most should go at the very bottom and in the flat area of the dirt. Be sure to create a nice variety of shapes and sizes to make the banks more interesting.

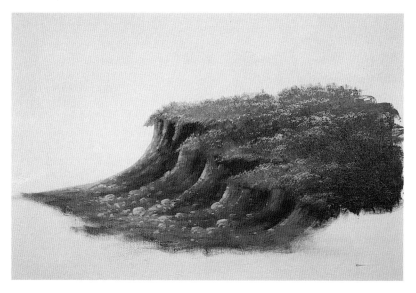

7. Highlight Grass

My favorite highlight color for grass is Phthalo Yellow-Green + a touch of Cadmium Orange + a touch of Hooker's Green. Make the mixture creamy and load the very tip of a no. 10 or no. 6 bristle. Dab the highlight on the grass, creating interesting pockets of negative space. You will add final highlights later, so just try to give the grass a little texture and three-dimensional feel in this step.

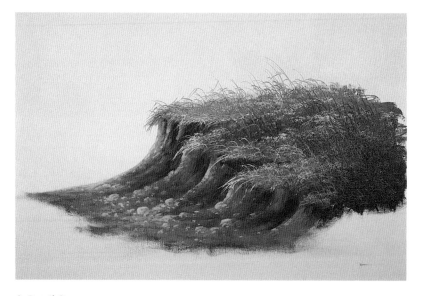

8. Detail Grass

You can use all your artistic license here. Mix your favorite brighter colors and use a no. 6 or no. 4 bristle to dab on these various highlights. This creates more interest and adds dimension to the grass area. Once again, be careful not to overdo it.

Create a very light mixture of Phthalo Yellow-Green + a touch of white. Then create a dark mixture of Hooker's Green + a touch of Dioxazine Purple. Thin both of these mixtures to a very inky consistency. Using these mixtures, take a no. 4 script liner and paint some taller weeds both standing and hanging over the banks.

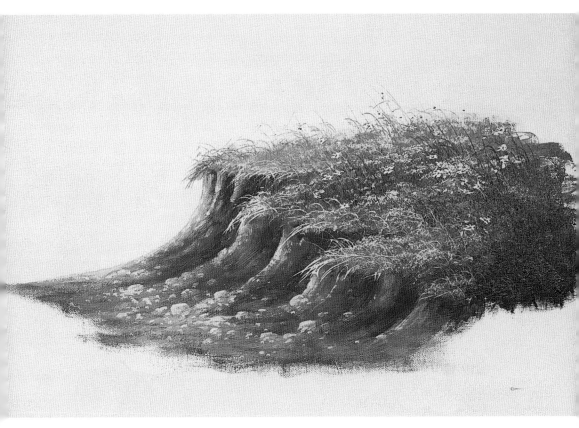

9. Add Final Details and Highlights

The white daisies are created using nothing more than pure white applied with a no. 4 round sable. Paint some small petals and then dab the small orange centers. To suggest wildflowers, pick up some pure color on a no. 4 bristle. The colors could be Cadmium Red Light, Cadmium Yellow Light, Cadmium Orange, a pink mixture, or any of your favorite colors.

Ocean Waves

I don't live near the ocean, and maybe you don't either. However, I highly recommend this study, even if you do not want to paint seascapes. This study contains many great instructional techniques that will, no doubt, help you in other areas of your painting. Please don't shy away from this one. It's a bit challenging, but the end result can be outstanding, and the satisfaction of knowing you did it will really build your confidence. Let's get to work!

1. Create Basic Sketch
Take your no. 2 soft vine charcoal and roughly sketch the main components of the seascape. You don't need great accuracy.

2. Paint Sky
Create a very creamy mixture of white + a touch of Cadmium Orange and Cadmium Red Light. Paint the entire sky area with a hake brush. While it's still wet, start at the top and add touches of Ultramarine Blue, Burnt Sienna (to turn it gray) and a touch of Dioxazine Purple (optional). Blend the colors downward, using large "X" strokes. Be careful not to blend too far down, or you will loose the nice, soft, peachy horizon. This is where the "three P's" apply: don't piddle, play or putter.

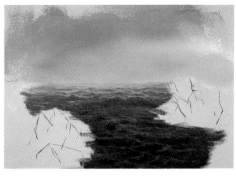

3. Underpaint Water

For the water, create a creamy, dark bluish green mixture from one part Ultramarine Blue + one-fourth part Hooker's Green + a touch of Dioxazine Purple. Begin applying the color with a no. 6 bristle using short, choppy, horizontal strokes. You want this to be very choppy, so don't be afraid to apply the paint fairly thickly, and remember to leave brushstrokes. Notice that at the horizon, the water is a little bit lighter. To achieve this look, add touches of white to the dark underpainting color as you recede into the background. This establishes gradual value changes from the darker foreground to the lighter background.

4. Highlight Water: Phase 1

This is where the challenge begins. First, take the dark mixture you used in step 3 and add white to lighten the value by about three shades. Make this mixture so creamy it is almost soupy. Load a small amount on the end of the bristles of a no. 4 flat sable. While holding the bristles horizontally to the canvas, begin making short, irregular, horizontal strokes, creating interesting pockets of negative space.

The challenge is to create good eye flow based on how you arrange the pockets of negative space. If you aren't careful, all the pockets of negative space will end up the same size and shape. Remember, this is moving water, so there will be very little symmetry in the shapes that the water creates.

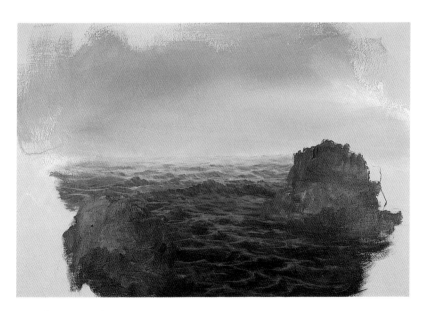

5. Underpaint Rocks

With a no. 6 bristle, pick up a little Burnt Sienna, a little Ultramarine Blue and a touch of Dioxazine Purple. Mottle these colors together on the canvas, filling all of the area where the rocks are. You can add touches of white to these mottled colors to make a few subtle value changes. It's OK to see lots of brushstrokes and to apply the paint thickly.

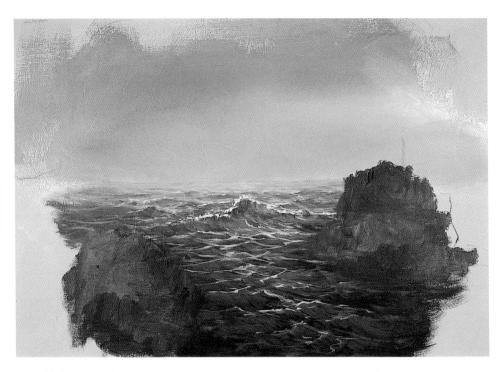

6. Highlight Water: Phase 2

Create a mixture of white with a slight touch of Ultramarine Blue to create a light bluish tint. Thin it to a very creamy consistency. Load a no. 4 round sable and highlight the ripples of the water. These are really the ridges on the edges of the negative space you created in step 4. This is also a good time to highlight the area on top of and around the main wave in the center.

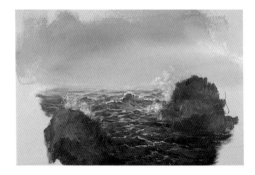

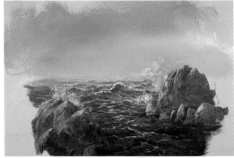

7. Add Splashes Behind Rocks

To add the splashes behind the rocks, mix white + a touch of Ultramarine Blue (basically the same mixture you used in step 6). With a no. 4 bristle, scrub this color behind the rocks. It's extremely important that you scrub this on in such a way to create very irregular shapes on the outer edges of the splashes. Be sure the edges are very soft and blended into the background. Usually when you apply an application like this and scrub it out, it will dry a little darker than you want, so don't be afraid to repeat this step a couple times to get it as bright as it needs to be.

8. Highlight Rocks

Mix white + a slight touch of Cadmium Orange and Cadmium Yellow Light. Dull this slightly by adding a small touch of Ultramarine Blue (this is called graying a color). Load a small amount on your no. 4 or no. 6 bristle. Keep in mind that the light is coming from the left side. Begin highlighting the rocks using short, choppy, vertical strokes that follow the contour of the rock formations. As usual, be careful not to cover up too much of the underpainting and not to clog up all the pockets of negative space. If you do, the rocks will lose their three-dimensional forms.

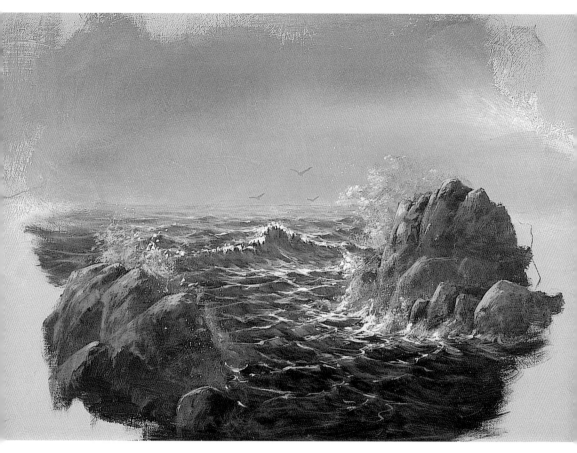

9. Add Final Highlights

Add water to pure white paint until it is very creamy, almost souplike. Load a toothbrush and spatter the areas around the splashes to suggest mist. Be careful not to overspatter the painting. Take pure white with your no. 4 bristle and smudge in the suggestion of splashes against the fronts of the rocks where the waves have crashed into them.

Now, it is simply a matter of rehighlighting any area you feel needs more light.

Running Water

Running water is one of the more fascinating components of a landscape. It adds interest, action and good entry into a painting, and streams and rivers often serve as the main center of interest. As appealing as running water can be in a landscape, if not done correctly, it can be more of a distraction than an asset. My goal is to teach you some techniques to help you add this running water to any landscape and make it look professional, eye-appealing and compositionally correct.

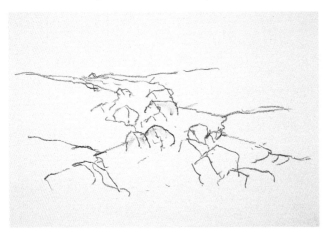

1. Create Basic Sketch

With a no. 2 soft vine charcoal, draw a quick, rough sketch of the basic layout of the stream. The sketch need not be accurate in the details, because shapes, forms and ground formations will change as you begin to paint.

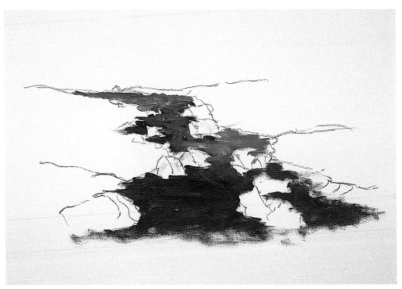

2. Underpaint Stream Bed

Create a very dark bluish green mixture of one part Ultramarine Blue + one-fourth part Hooker's Green and then divide it into two piles. To one pile, add about one-fourth as much white to create a lighter value. With a no. 4 bristle and the lighter value, paint in the back half of the stream using short, choppy, horizontal strokes.

As you come forward, begin adding the darker mixture (from the second pile) using the same strokes. It's fine if the water looks choppy—this adds to the movement of the water.

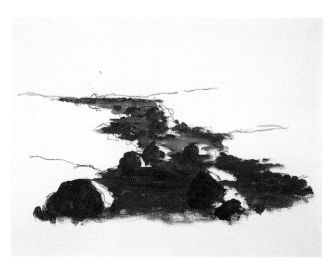

3. Underpaint Rocks

Create a very dark mix of one part Burnt Sienna + one-fourth part Ultramarine Blue + a touch of Dioxazine Purple. Underpaint each rock with a no. 4 or no. 6 bristle. Again, it's OK for brushstrokes to show, in order to give the rocks a little texture. Remember, you want a wide variety of shapes and sizes.

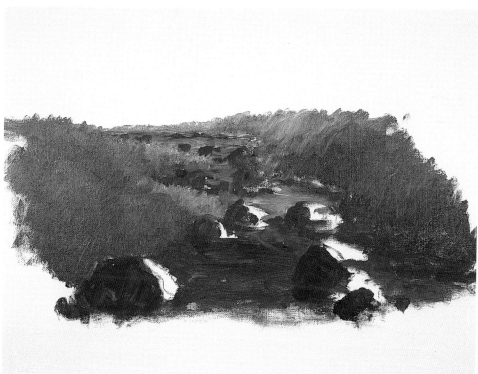

4. Underpaint Grass

This type of grass is used in earlier studies, so you should be familiar with it. Starting at the back and on both sides of the stream, paint on Phthalo Yellow-Green and touches of Hooker's Green with a no. 10 bristle. Apply the colors fairly thickly and then mottle them together. While the paint is still wet, take your brush and push the color upward, creating a grasslike texture. As you come forward, begin adding more Hooker's Green, Burnt Sienna and touches of Dioxazine Purple to the mixture so it becomes a dark forest green. The paint must be fairly thick in order to leave a texture when you push it up with your brush.

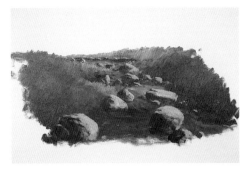 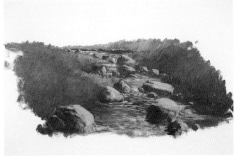

5. Highlight Rocks: Phase 1

To create a soft, warm highlight for the rocks, take a little bit of the original rock underpainting color used in step 3, and add half as much white and a touch of Cadmium Orange. This is not the final highlight color, so don't make it too bright. Load a small amount on the tip of a no. 4 bristle and paint a highlight on the top-right side of each rock. Remember to allow some of the underpainting color to show through to create a more three-dimensional look.

6. Highlight Water: Phase 1

This is one of the most important steps to help make the water look as if it's moving. Create a highlight color of one part Ultramarine Blue + one part white + about one-eighth part Hooker's Green. Take a little bit of the mixture and thin it to a very, very creamy consistency. Then load a small amount on the tip of a no. 4 flat sable. Hold the brush horizontal to the canvas and apply the highlight color using short, choppy, horizontal strokes. Notice that the strokes are very irregular, with interesting pockets of negative space. Be very careful not to overhighlight and, as a result, cover up too much background.

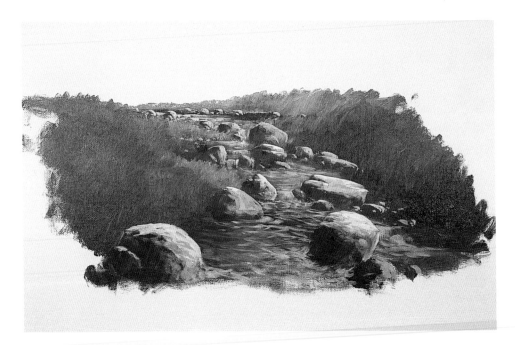

7. Highlight Rocks: Phase 2

This step brightens the rocks. I have a fairly standard highlight color I use for most rocks. Mix white with a slight touch of Cadmium Orange; you could add a touch of Cadmium Yellow Light to create more of a golden tint. Make this mixture very creamy. Load a small amount on the tip of a no. 4 flat sable and carefully apply this color on the areas that have already been highlighted, but still allow some of the underpainting to show through. Use short, choppy strokes to create texture.

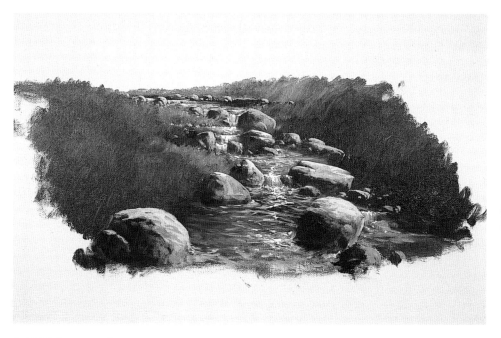

8. Highlight Water: Phase 2

This is a simple but important step. Add a very small touch of Cadmium Yellow Light to white to create a whitish yellow tint. Keep in mind you are not creating a color but rather a tint. Make the mixture extremely creamy. Put a somewhat heavy load on a no. 4 round sable and apply these highlights to the center areas of the water where it moves around the rocks and on the small waterfalls. This highlight needs to stay very clean and bright as well as very opaque, so reload your brush often. Don't be afraid to repeat this step one or two more times in certain areas to be sure you get it as bright as you need it.

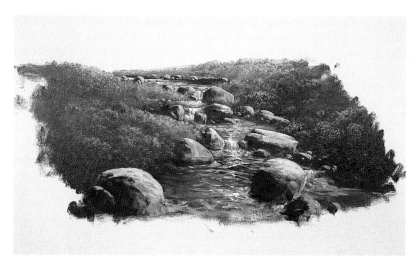

9. Highlight Grass

Create a creamy mixture of Phthalo Yellow-Green + a touch of Cadmium Orange. This creates a very nice, soft hue similar to a mustard color. Load the very tip of a no. 6 bristle and dab the color onto the grassy areas, following the contour of the land as it goes in toward the water. As always, be sure you create very interesting pockets of negative space so your eye flows gracefully around the grassy areas.

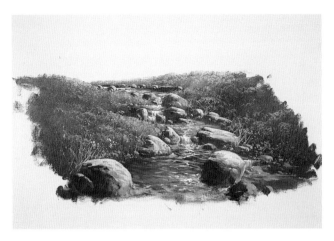

10. Add Final Details and Highlights

What you do in this step is really up to you. You can dab on a few bright, miscellaneous flowers of any color you choose. You can use your no. 4 script liner to create a couple light and dark inky mixtures and use them to add some taller weeds, especially toward the front of the stream. You may want to highlight your rocks a little brighter and also brighten the highlights on the water.

Peaceful Waters
12" × 16" (30cm × 41cm)

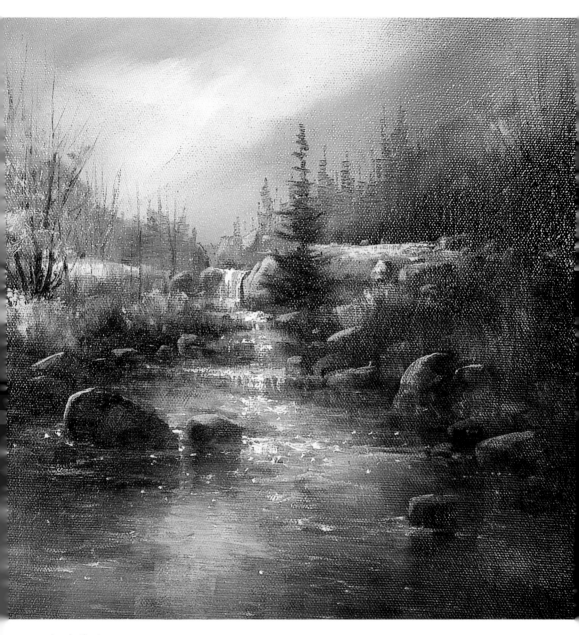

Apply the Lesson

There are many different ways to apply and use this study on running water. In a work of art, running water need not be turbulent or crashing over boulders to seem lively. The painting you see here, *Peaceful Waters*, was a small *plein air* painting done in oil. (*Plein air* means the painting was done outdoors and on location.) In this painting, the water is a gently moving stream with just enough ripples to create a peaceful, relaxing atmosphere. The technique we use in this study is the same used in this lovely plein air piece.

Reflections in Water

Reflections are necessary in any landscape containing still water. However, learning how to paint reflections is, by far, one of the more challenging techniques in landscape painting. The process is really quite simple, but students tend to make it more complicated than it needs to be. This is a very simple study, designed only to show technique. The technique applies to any calm water you may add to your paintings. The real challenge is making the reflections appear very wet.

1. Create Basic Sketch
Use your no. 2 soft vine charcoal to draw a very rough, simple sketch of the main components of the landscape. Locate the horizon line.

2. Underpaint Sky and Water
We paint the sky and water at the same time because the water must have a hue similar to the sky. Mix white with a touch of Cadmium Orange to create a soft, very creamy horizon color. With a hake brush, paint this color about halfway up the sky and halfway down in the water using large "X" strokes. While the horizon color is still wet, mix white with a touch of Ultramarine Blue. Quickly use your hake brush to blend this color from the top of the sky down into the peach-colored horizon. Do this same thing in the water, but go from the bottom upward. Be sure everything is blended very softly.

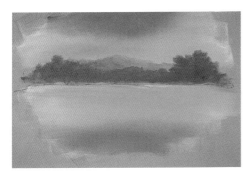

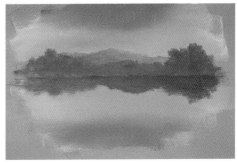

3. Underpaint Background

Make a soft, mauve gray from white + touches of Dioxazine Purple, Ultramarine Blue and Burnt Sienna (it will need to be a value about two shades darker than the horizon). Use a no. 4 bristle to paint in the background mountain.

Darken the mixture by adding a little Hooker's Green and a touch of Dioxazine Purple. This should be a grayish green about two shades darker than the background. Paint in the midground trees and mountain. Be sure you keep the edges very soft.

4. Underpaint Reflections

For these reflections, add a little white to the colors used in step 3 to slightly lighten the value and make it very creamy. Load a very small amount on a no. 4 bristle and scrub in the basic shape of the trees and mountains. The mixture has to be just the right consistency for this to work properly, so you may need to experiment a little bit. As before, it's very important to make the edges of the reflections very soft.

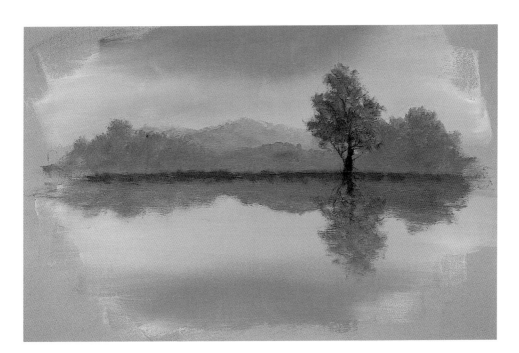

5. Paint Shoreline and Tree

To smudge in a dark underpainting for the shoreline, darken the color you used in step 4 by adding a little more Burnt Sienna, Hooker's Green and Dioxazine Purple. Scrub this color on the shore with a no. 4 bristle. Keep the edges very soft.

Use this same color and a no. 4 round sable to paint the tree trunk and its reflection. For the tree's foliage, add a little white to this same mix to slightly lighten it. Add a little Hooker's Green to create a grayish green. Use a no. 4 bristle to scrub in the foliage and the reflection. Be sure the reflection is very, very soft.

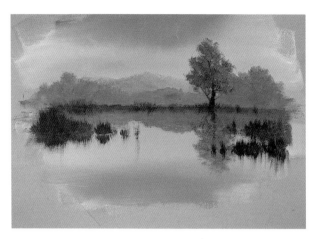

6. Add Clumps of Grass

Darken the mixture used for the tree in step 5 by adding a little more Hooker's Green and a touch of Dioxazine Purple. Load a small amount on the tip of a no. 4 bristle. Decide where you want to place grass clumps and place the brush vertical to the canvas. Pull up with short, vertical strokes, creating the suggestion of grass. After you pull up, immediately pull downward with the same stroke to create the reflection.

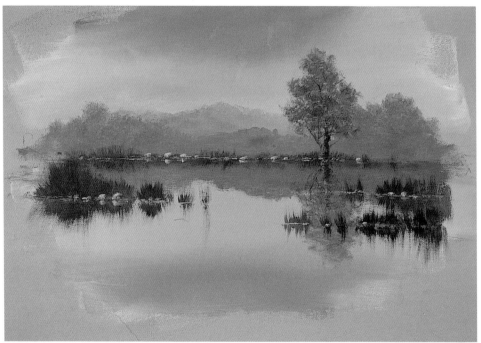

7. Highlight Shoreline and Trees

To suggest rocks along the shoreline, mix white with a touch of Cadmium Orange and dull it down a bit with a little Ultramarine Blue. Load a very small amount on a no. 4 flat sable and paint along the shoreline using short, choppy, broken strokes. Do this also at the bases of the clumps of grass. Make a few larger smudges to create some slightly larger rocks.

Mix Phthalo Yellow-Green + a touch of Cadmium Orange. With a no. 4 bristle, dab a few highlights on the left sides of the tree leaves to create a little more form. Do this on the background trees and their reflections, as well.

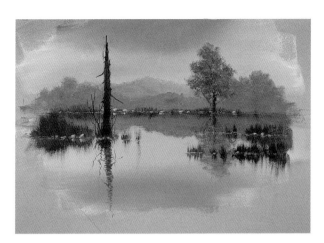

8. Paint Dead Stump and Reflection

This stump is another opportunity to add a reflection to the water, so keep it simple. Mix one part Burnt Sienna + one part Ultramarine Blue. With a no. 4 flat sable, underpaint the stump, using short, choppy, vertical strokes.

Slightly lighten the value with a little white. Load a no. 4 flat sable and use short, horizontal strokes to paint in the reflection. The reflection should have a bit of a blurry appearance, and it should not be painted on too solidly. Let a little of the background water show through.

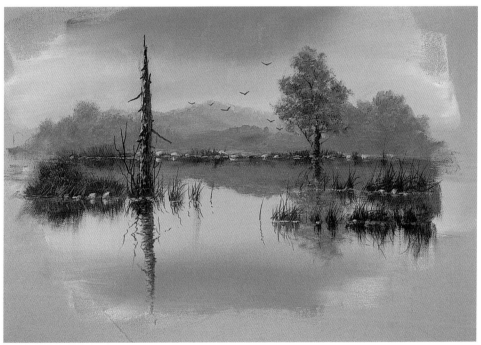

9. Add Final Details

First, highlight the dead tree and the trunk of the live tree. Mix white + a touch of Cadmium Orange. Load a no. 4 round sable and use short, choppy strokes to create the highlight and barklike texture on the left side of the dead tree. Don't forget to highlight the reflection and to put a little highlight on the trunk of the live tree.

Mix a little Hooker's Green + Dioxazine Purple and thin it to an inklike consistency. Load a no. 4 script liner and paint in some tall weeds around the grass clumps. Then paint the reflections of the weeds in the water.

You also can add miscellaneous details and highlights to suit your own personality. For instance, you can highlight the clumps of grass, highlight the middle background, add birds, etc.

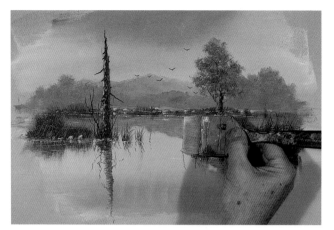

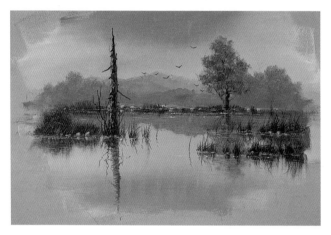

10. Glaze and Highlight Water

Create a very thin wash of water and a little bit of pure white. Load the very chisel edge of a hake brush and turn it vertically to the canvas. Lightly touch the canvas then slightly wiggle your brush up and down as you drag it sideways across the surface of the water. The top photo shows this in progress. Wiggling will create a slightly rippled effect and soften any reflections that are too dark.

Load a no. 4 round sable and paint some short, choppy, horizontal strokes along the shoreline and the bases of your clumps of grass. This creates the suggestion of ripples and helps separate the water from the ground.

The bottom photo shows the finished study.

Peace Be Still
12" × 16" (30cm × 41cm)

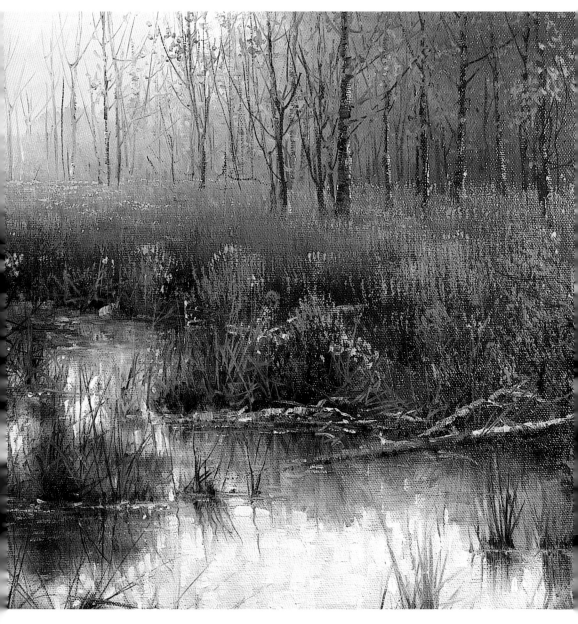

Apply the Lesson

This study of reflections mostly concentrates on a very simple application in a clear, calm body of water, but there are many different applications for this technique.

I thought it might be fun to show you a finished painting that includes this refection technique. This painting, *Peace Be Still*, is a swamp scene that caught my eye one day as I was on a research trip. Not only were the flowers really spectacular, but the reflections interested me the most. I used the same technique that I showed you in this study to create this beautiful, muddy pond.

Clouds and Rainbows

Not only will this study teach you how to create the perfect cloudy sky for your paintings, but you will also learn how to paint a realistic rainbow. A rainbow's arch can be very difficult to paint and becomes a problem for many artists. Keeping the form correct and making the colors appear transparent can be quite challenging. This study will help you understand the proper way to create an accurate arch and transparent colors. Another benefit of this study is learning how to create an entire landscape to have the proper background to fit the rainbow.

1. Create Basic Sketch
With a no. 2 soft vine charcoal create a rough sketch of the general layout of the landscape.

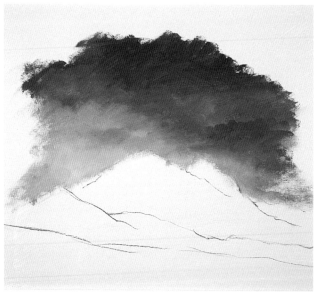

2. Underpaint Sky
We need to create a semi-stormy sky in this step, which requires the mottling of several colors. First, mix a basic gray of one part Ultramarine Blue + one-fourth part Burnt Sienna + one-fourth part white + about one-eighth part Dioxazine Purple. Next, mix a light pink of white + a touch of Cadmium Red Light.

Load some of the pink mixture on a no. 10 bristle and scrub on this color at the base of the sky. As you work your way up, start adding some of the gray mixture, creating various light and dark values (this will suggest clouds). You can now switch to a no. 6 bristle and create more distinct clouds, if you wish.

Landscape Secret
A soft whitish underpainting will make the colors in your rainbow stand out.

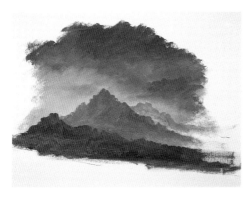

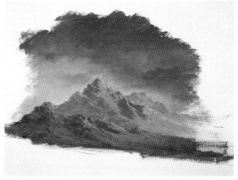

3. Underpaint Mountains

There are three different values in the mountains. To create these values, add a bit more white and a touch of Dioxazine Purple to the base gray you used in step 2. This is value one. Load this value on a no. 4 bristle and paint in the most distant mountain.

Take the base gray from step 2 and use it pretty much as it is for the midground mountain. However, if it appears too dark, add a touch of white to change the value.

For the foreground mountain, take the base gray and darken it with a little more Ultramarine Blue, Burnt Sienna and Dioxazine Purple.

4. Highlight Mountains

Create a mixture of white with a touch of Cadmium Orange. The secret to highlighting is how much water you put in the mixture. For the background mountain, thin the mixture so it is fairly transparent, and highlight the right side with a no. 4 flat sable. A more transparent mixture allows the background to show through, thus creating a softer highlight.

For the midground mountain, use less water so the highlight is more opaque. This will make the highlight a little brighter.

Add a touch more Cadmium Orange to the mixture for the foreground mountain's highlight.

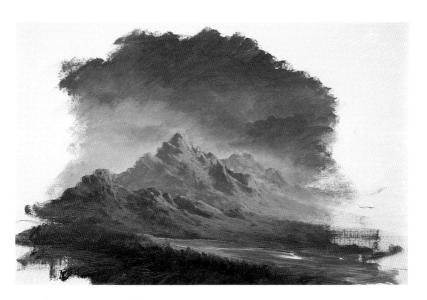

5. Underpaint Foreground

Mottle Phthalo Yellow-Green + a little Hooker's Green on the canvas using long, horizontal strokes. Apply a fairly thick amount of paint to leave a little texture. Don't be afraid to add a touch of Cadmium Yellow Light here and there to create a few bright spots.

In the immediate foreground, mix one part Hooker's Green + one-fourth part Dioxazine Purple + one-fourth part Burnt Sienna. Then take a no. 10 bristle and scrub the mixture in the lower left-hand corner to suggest small bushes and grass. Don't be afraid to put the paint on fairly thickly.

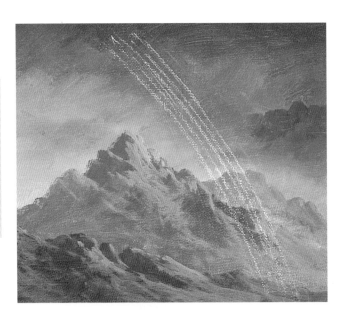

6. Sketch in Rainbow

Once the background is completely dry, use a white Conté pencil to sketch the arch and the width of the rainbow. Sketch very lightly. The Conté pencil wipes off easily with a damp paper towel, so feel free to make several attempts to get it correct.

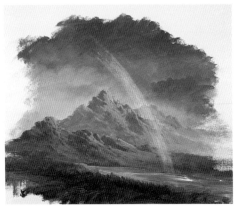

7. Underpaint Rainbow

The secret to the colors on the rainbow is to have a soft, whitish background for them. Load a very small amount of gesso on a no. 4 bristle and then wipe off most of it. Following the shape of the sketch, begin drybrushing the gesso on the rainbow, creating a very soft underpainting. It is absolutely critical there are no hard edges on both sides of the rainbow! Carefully feather out the edges.

8. Add Color to Rainbow

This step uses the same techniques as step 7, but this time you will add actual color. Start on either side of the rainbow (the red side or blue side). Premix the three colors you will be using: Cadmium Red Light + a touch of gesso; Ultramarine Blue + a touch of gesso; and Cadmium Yellow Light + a touch of gesso. Load a very small amount on a no. 4 bristle and carefully drybrush the color on the rainbow using long, sweeping strokes. Be sure you use one continuous stroke for each color. Also, make sure your brush is fairly dry. Repeat this step for each color, being very careful not to leave any hard edges.

9. Highlight End of Rainbow and Midground Mountain

Usually there is a splash of bright light on the objects surrounding the rainbow's end. To accomplish this effect, take Phthalo Yellow-Green with maybe a little Cadmium Yellow Light and make the grassy area at the end much brighter. Mix white + a touch of Cadmium Orange to highlight the base of the mountain and smaller rocks. A no. 4 bristle works best for these highlights. Make this area as bright as you want; it will add great drama to the painting.

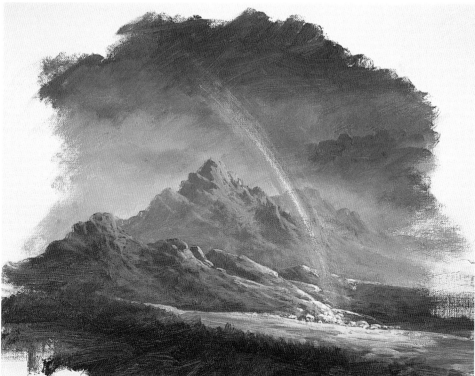

10. Brighten Rainbow

Once the paint dries, you probably will need to brighten your rainbow. To do this, repeat the process you used in step 8. Remember to use long, continual, sweeping strokes with very little paint on the brush. Before you brighten, it's probably a good idea to practice on a scrap canvas until you get the hang of it. If you make a mistake, take a little gesso and drybrush over the rainbow. Then start over.

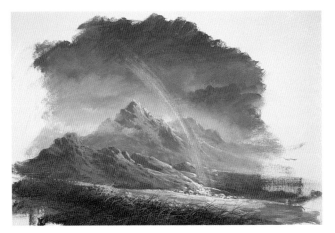

11. Add Final Details and Highlights

Brighten the area behind the mountain with a no. 4 bristle and a mixture of white with a slight touch of Cadmium Orange and Cadmium Yellow Light. Scrub on the color and feather it out to create a brighter, soft glow.

To add a few tall weeds in the foreground, create a light, inky mixture of Phthalo Yellow-Green + a touch of Hooker's Green, and place the weeds wherever you wish. Make a dark mixture of Hooker's Green and a little Dioxazine Purple for the darker weeds.

To finish, dab on a few little wildflowers and just have fun adding whatever details make you happy.

End of the Rainbow
24" × 30" (61cm × 72cm)

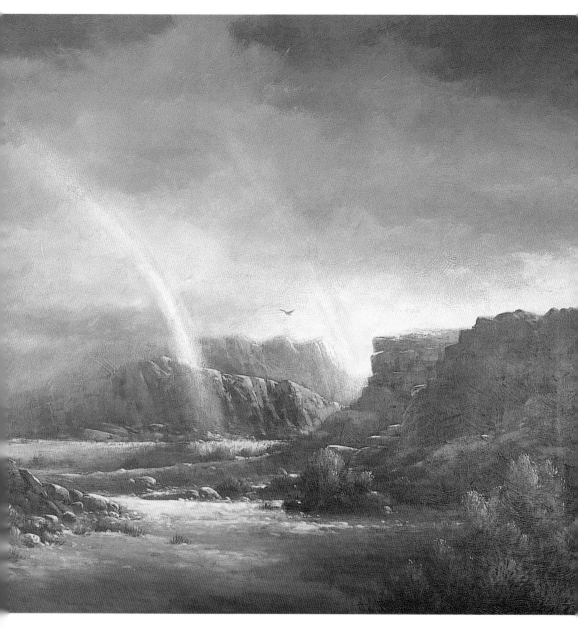

Apply the Lesson

This painting is a great example of how a beautiful rainbow can add tremendous drama and atmosphere. Depending on the composition, it can actually become the center of interest for certain paintings. Rainbows also help add color harmony.

Leafy Trees

For some people, nothing is more pleasing to look at in a painting than a beautiful, leafy tree. Of course, there are all kinds of varieties of trees, and it would be impossible to show all the different types in this book. This study simply teaches a basic technique you can apply to most types of leafy trees; change the size, shape and color to the appropriate type of tree. This technique also works well for small bushes.

1. Create Basic Sketch
Use a no. 2 soft vine charcoal to roughly sketch the basic, general shape of the tree.

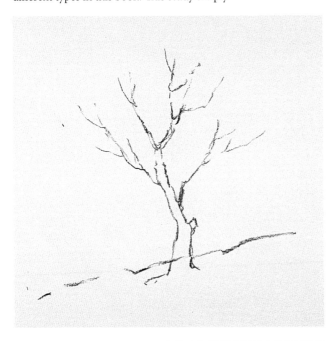

2. Block in Tree Trunk
Add a little water to plain Burnt Umber to make the paint creamier. Load a no. 4 flat sable to block in the basic shape of the trunk. Switch to a no. 4 round sable and add just a few minor limbs. It's important not to add too many limbs at this stage because you will add the final limbs after the tree leaves have been completed.

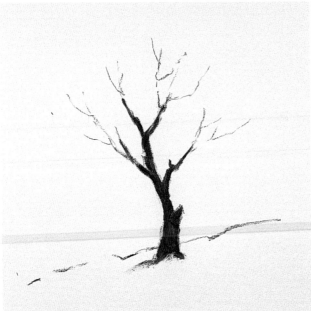

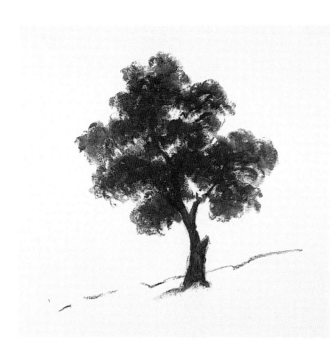

3. Underpaint Leaves

Create the basic tree color by mixing one part Hooker's Green + one-fourth part Burnt Sienna + about one-eighth part Dioxazine Purple. This should create a very deep, dark forest green which can vary depending on how much Dioxazine Purple or Burnt Sienna you mix in. To change the value, add whatever amount of white you need. Load the tip of a no. 6 or no. 10 bristle, depending on the size of the tree and the clumps of leaves you want. Begin dabbing straight on the canvas at the center of the tree and gradually work your way outward to shape it as you desire. Remember to create interesting pockets of negative space around and through the tree.

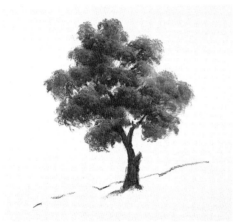

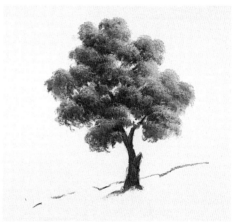

4. Highlight Leaves: Phase 1

It's time to decide on a light source. I chose to have the light come from the upper-right side. Take your original dark mixture from step 3 and add a little bit of Phthalo Yellow-Green, a little white and maybe a little Cadmium Orange or Cadmium Yellow Light, depending on the color and value you need. In this case, the highlight should be about two or three shades lighter than the original mixture.

Load the end of a no. 6 bristle and carefully dab the highlight on the upper-right side of each clump. Use a light touch to create a light, leafy texture.

5. Highlight Leaves: Phase 2

Lighten the mixture you used in step 4 by adding more Phthalo Yellow-Green, Cadmium Yellow Light and white. Load a no. 4 or no. 6 bristle and repeat the highlighting process from step 4 to create the next value of light. How much light you choose to use is up to you, but be careful not to overhighlight, or your clumps will become a solid mass. The next step will be the final highlight.

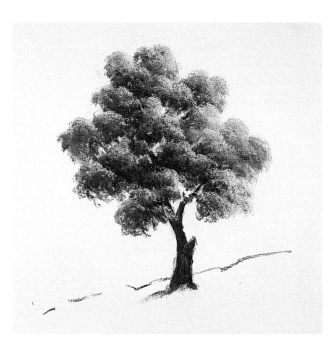

6. Highlight Leaves: Phase 3
You have several choices in this step: You can mix one part Phthalo Yellow-Green + one part white, or one part Cadmium Yellow Light + one part white, or any number of very light colors, as long as they are significantly lighter than the previous highlight. Load the tip of a no. 4 bristle and very lightly dab the outer edges of the clumps. Once again, be careful not to overhighlight.

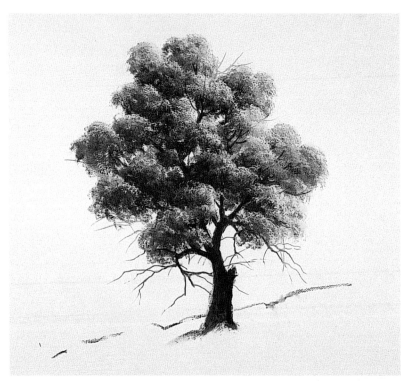

7. Add Tree Limbs
Add plenty of water to pure Burnt Umber to make a very thin, inklike mixture. Roll a no. 4 script liner in the mixture until a nice point is formed. Paint in all the tree limbs within the structure of the tree. Keep an eye on the negative space as you add the limbs so the leaves look connected to the tree.

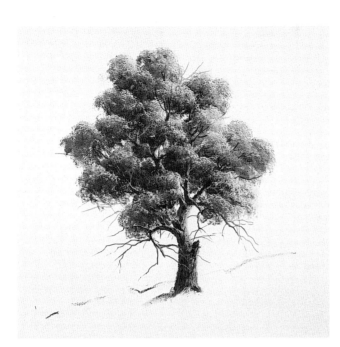

8. Highlight Tree Trunk

Mix one part white with about one-eighth part Cadmium Orange, and add water to make the mixture very creamy. Load a no. 4 round sable, and, using short, choppy, vertical strokes, highlight the right side of the tree trunk and any major limbs. When this highlight dries, it may lose some of its brightness, so don't be afraid to repeat this process once or twice to achieve the brightness you're after.

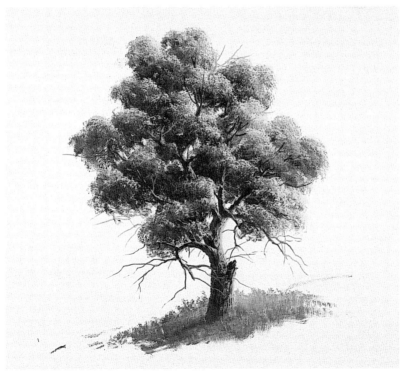

9. Paint Grass Under Tree

Because this is a study, you need only to scrub in some grass at the base of the tree. Take some Phthalo Yellow-Green with a little Hooker's Green and maybe a little Cadmium Orange. Paint this on by mottling it in a fairly thick layer using a no. 6 bristle. While the paint is still wet, put your brush flat against the canvas and push the color upward, creating a soft, grassy texture.

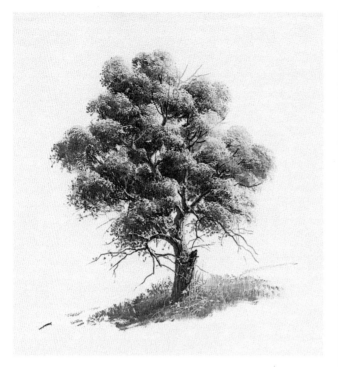

10. Add Final Details and Highlights

A little artistic license is in store here: You can add a few flowers of any color. Load a no. 4 bristle and dab on a few clean, bright, delicate flowers. Create an inky mixture of some dark and light colors, and paint in a few taller weeds with a no. 4 script liner.

Autumn Wonders
12" × 16" (30cm × 41cm)

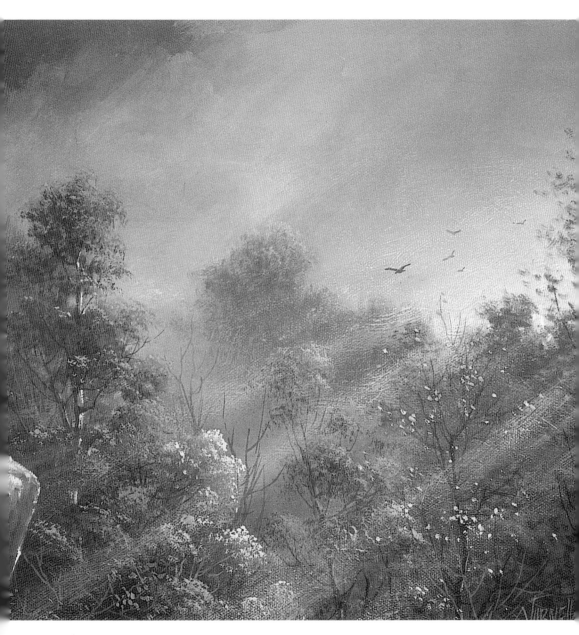

Apply the Lesson

This study shows you a technique for creating leafy trees in summer with spring, greenish tones. I thought you might enjoy seeing a collection of trees instead of one lone tree. *Autumn Wonders* was inspired by a spot near my studio in the Osage hills, which features a large variety of trees and shows autumn colors you can paint with this same technique.

Dead Trees

I'm happy to show you how fun it can be to paint dead trees. Dead trees are wonderful assets to any landscape painting, and they are a great compositional tool—wonderful for creating pockets of negative space and breaking up negative space. They also add great charac-ter and interest to a landscape. You can make textured bark or smooth bark on dead trees. Plus, there are many varieties and shapes that will give you a wide array of opportunities to really improve your painting. This study focuses on dead pine trees.

1. Create Basic Sketch
Use a no. 2 soft vine charcoal to make a rough sketch of the tree's basic shape. (Note: It is best to make the sketch of the tree a little bit smaller than the actual finished tree will be. The tree tends to expand as you apply the paint.)

2. Underpaint Trees
Pick up Ultramarine Blue, Burnt Sienna and a little Dioxazine Purple on a no. 4 bristle. Mottle these colors on the tree using short, choppy, vertical strokes. If you like texture, don't be afraid to apply the paint fairly thickly. However, be careful not to overblend, or it will all turn into one color.

Switch to a no. 4 round sable and paint in the stumpy branches. You will add the longer branches in a later step.

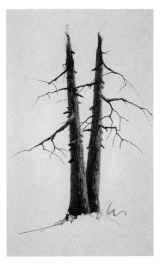

3. Highlight Trees

Highlighting the tree gives it the suggestion of tree bark and sunlight. Mix white with a touch of Cadmium Orange and a slight touch of Burnt Sienna. Add water to make the mixture creamy. Load a no. 4 round sable and begin highlighting by using short, choppy, vertical strokes. Go up and down the right side of the tree, leaving small pockets of negative space to help suggest the texture of bark. Gradually work your way across the tree until the highlight fades into the dark side. If the highlight dries too dull, you can go over it one or two more times until you are happy with the brightness.

4. Add Reflected Highlight

I have discussed the use of reflected highlights before in some of my other books and other studies. In this step, we use a soft, cool, reflected highlight. This highlight will be on the shadowed side of the trees to help create a rounded appearance. This reflected highlight is especially effective on large tree trunks that have a darker, shadowed side.

Create a mixture of one part white + one-fourth part Ultramarine Blue + a touch of Dioxazine Purple. It should be a fairly deep medium, bluish purple; be careful it's not too white. With a no. 4 round sable, apply this color on the very edge of the shadowed side and then gradually work it over to the center of the tree. Be very careful not to make this highlight too solid. Leave little pockets of negative space, just like you did when applying the warm highlight on the right side.

5. Add Final Tree Limbs

Mix equal parts Ultramarine Blue and Burnt Sienna, and add water to create a very thin, inklike mixture. Roll a no. 4 script in the mixture until a nice point is formed. Continue finishing out the limbs you began in step 2. Remember to make interesting shapes, allowing some of the limbs to overlap each other, which will create interesting pockets of negative space.

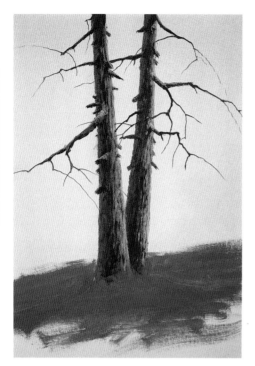

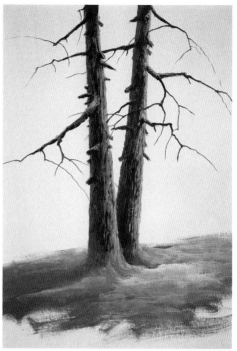

6. Underpaint Snow at Base of Tree

Though this study is mostly about the trees, it's important to know how to place the trees on the ground. Mix Ultramarine Blue + a touch of Burnt Sienna + a touch of Dioxazine Purple and just enough white to create a medium-value, purple bluish color. With a no. 4 bristle, scrub this shadow color all along the base and behind the tree. Drift this color up against the side of the tree to make it appear as if the trunk is settled in the snow.

7. Highlight Snow: Phase 1

Add a very slight touch of Cadmium Orange to pure white to create a tint rather than an actual color. Thin the mixture with water until it is very creamy. Load a small amount on the end of a no. 4 bristle and begin scrubbing on the highlight, creating little mounds of drifted snow. It's especially important to drift this up against the right side of the tree base. If you happen to overhighlight and lose the pockets of negative space, take the gray underpainting color from step 6 and paint out that area to start over.

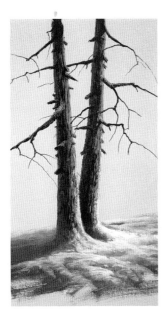

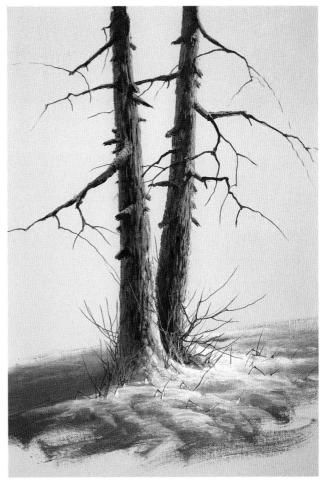

8. Highlight Snow: Phase 2

This is a very simple step, basically called spot highlighting. Load the tint from step 7 on a no. 4 flat sable fairly heavily. Pick selected spots you want to give a much brighter highlight and rehighlight these areas using much thicker paint. The brightness of the snow is up to you. Have fun, but be careful not to overdo it.

9. Add Grass, Weeds and Final Highlights

This step is quick. Mix Burnt Sienna with a little bit of Ultramarine Blue to create a dark brown. Use water to thin the color to a very thin inklike consistency. Roll a no. 4 script liner in this mixture until the brush forms a sharp point. Paint in the weeds and dead bushes. Don't hesitate to add more limbs on the main tree. After you finish, add some very clean, bright highlights at the base of the weeds and bushes, using the highlight color from step 8 and a no. 4 round sable. This will add a little sparkle to the snow.

Falling Snow

You may not be a "snow person," but the process of creating falling snow is one of the more fun things you will paint. The process is very simple and effective. It is simply a matter of creating a very thin wash and then taking your toothbrush and spattering some snowflakes. Falling snow adds a little drama, or a peaceful effect, to a snow scene, depending upon how you look at it. This study takes only three steps, so it's a quick and easy thing to learn.

1. Paint Background

Begin with a grayish, mottled background. Create a mixture of one part Ultramarine Blue + one-fourth part Burnt Sienna + about one-fourth part white + a touch of Dioxazine Purple. Make this mixture nice and creamy. Load your hake brush and paint the background using large "X" strokes. If the background is too dark, add a little white as you go, or you can even add some of the other colors if you need to change the hue. The important thing is that the background is not too light.

2. Paint Wash and Flick Snow

Before you start this step, be sure the background color is completely dry. Premix the snow color, which is nothing more than white with enough water to make it fairly soupy. Let that mixture set for a second and then load a hake brush and put a thin wash of water and a slight touch of white all across the background.

While the wash is still wet, load a toothbrush with the snow color and run your forefinger across the bristles, spattering the snowflakes on the wet background. Notice that they begin to bleed a little bit, which is OK. The bleed creates the softer, more distant snowflakes. You will probably need to experiment with this technique to get the hang of it. The final results depend on how close you hold the brush to the canvas when you spatter and how soupy your snow mixture is. This determines how large or small the snowflakes will be.

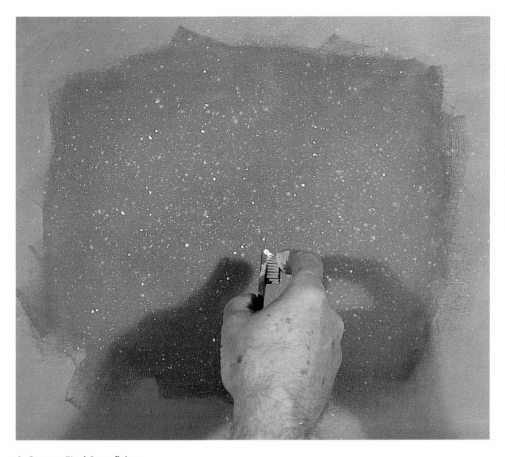

3. Spatter Final Snowflakes

These final snowflakes will be the close-up, more distinct snowflakes. The canvas should be completely dry, which will keep these new flakes clean and bright. Create a soupy mix of water and white paint. Load the toothbrush and spatter the canvas, holding the brush close to the canvas.

HIGH-COUNTRY WATERFALL

If you've been studying my books or following my television show for very long, you already know I love to paint mountains and waterfalls—especially when they're combined. This waterfall scene is similar to another waterfall I did in my first book, *Painting Basics*. However, I chose to do this type of scene again because it fits so well with many of the studies you have learned in this book, including rocks, dead trees, grass, clouds, and running water.

Plus, this particular painting is a little more advanced and will have more comprehensive explanations accompanying it. It will be a fairly challenging painting, but the learning experience will be well worth all the effort you'll put into it. Grab your brushes and some courage and let's get started!

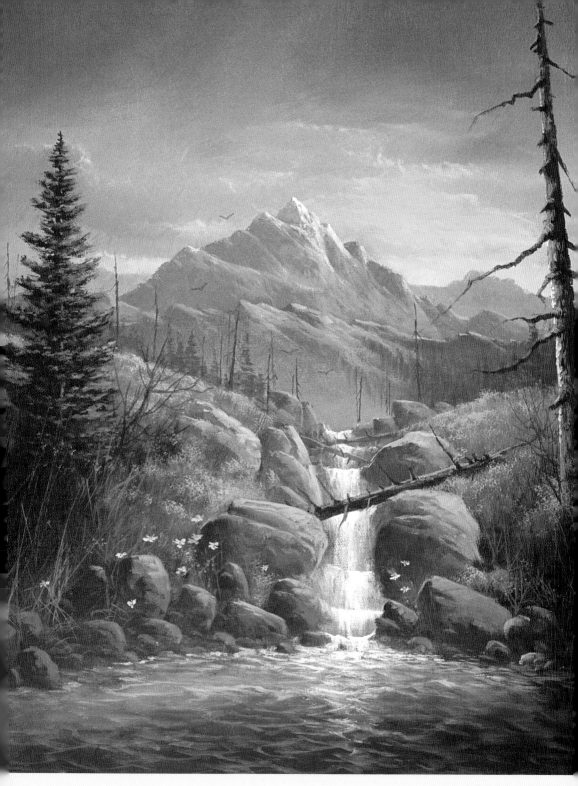

High-Country Waterfall
20" × 16" (51cm × 41cm)

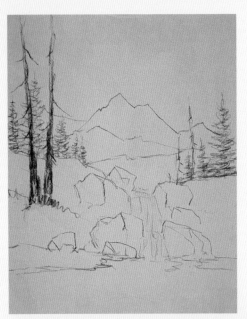

1. Create Basic Sketch

Normally I suggest that your sketch doesn't need to be too accurate, but, because the composition is more complicated in this painting, it's probably a good idea to spend a little more time making sure you're very satisfied with the arrangement of objects. If you're pleased with your sketch, you won't need to alter things too much when you get further along in the painting. As always, use a no. 2 soft vine charcoal for the sketch.

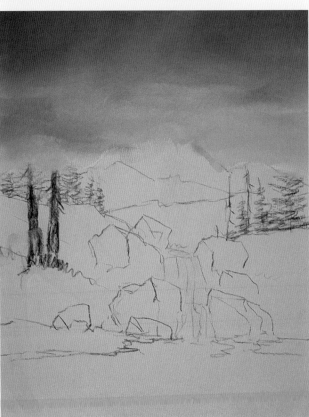

2. Block in Sky

You will create two color mixtures. The first is a nice, soft, golden hue for the horizon: Mix one part white + about one-eighth part Cadmium Yellow Light + about one-eighth part Cadmium Orange. Create the darker mixture of one part Ultramarine Blue + one-eighth part Burnt Sienna + one-eighth part Dioxazine Purple + about one-fourth to one-half part white, depending on the value you desire. Make both mixtures very creamy.

Load a hake brush with the horizon color and paint large "X" strokes all the way to the top of the canvas. While this color is still wet, start using your darker mixture at the top and begin blending downward, creating irregular pockets of negative space to suggest somewhat stormy clouds.

3. Finish Sky
Make sure the sky is quite dry before you start this step, which gives the sky a much brighter glow. Load a no. 4 flat sable with the horizon color. Starting at the area just behind the mountain, apply the color and carefully blend it along the base of the sky. You want the sky to be a little brighter on the right side, just behind the large mountain. You can make this sky as bright as you want, so don't be afraid to repeat one or two more times. Take your no. 4 round sable and paint a silver lining along the edges of some of the darker clouds using the horizon color.

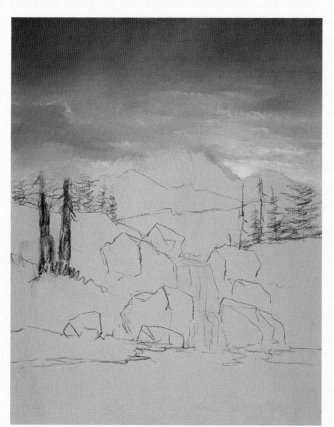

4. Block in Background Mountain
Use a no. 4 flat bristle to paint in the mountain farthest away. You can use the dark mixture from step 2 if it's the correct value (it needs to be about two to three shades darker than the sky). However, if the mixture is too dark, add a little white to change the value.

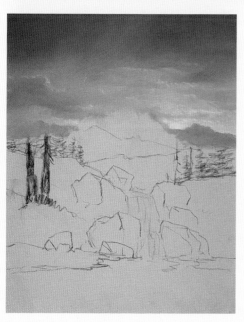

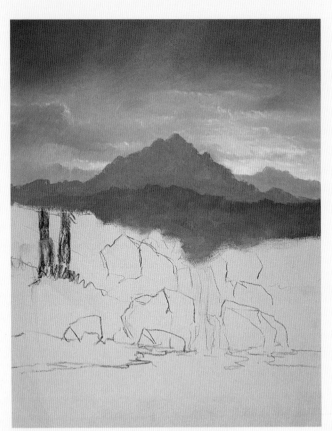

5. Block in Midground Mountains

Darken the mixture you used in step 4 by about two values by adding a little more Dioxazine Purple, a little more Ultramarine Blue and a little more Burnt Sienna. Load a no. 4 bristle and paint in the midground mountain. Make sure the mountain has an interesting shape. Take the same mixture and darken it a little more. Using the same brush, block in the very foreground mountain.

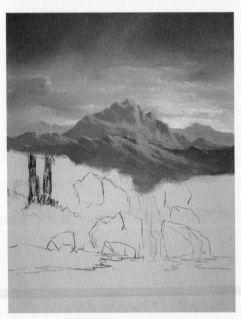

6. Highlight Mountains: Phase 1

Create a highlight color of white + a touch of Cadmium Orange. Thin the mixture so it's very creamy. This is only phase 1 of establishing the basic structure of the mountains, so don't highlight too brightly yet. Allow more moisture on your brush and use less paint to assure the highlights are not too bright.

Load a small amount on your no. 4 bristle or no. 4 flat sable (you may want to test to see which one works best for you). Paint the highlights, creating very interesting pockets of negative space, giving the mountains the appearance of being three-dimensional.

Paint the very front mountain the same way, but add a little more Cadmium Orange to the mixture.

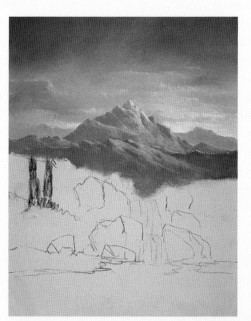

7. Highlight Mountains: Phase 2

Be sure you are pleased with the way you shaped your mountains in step 6 before you begin the second phase of highlights. Take the same mixture you created for the foreground mountain highlights and increase its intensity by adding a bit more white and a bit more Cadmium Orange. Apply the highlight a little more opaquely so the result will be brighter. Load a no. 4 flat sable and rehighlight the areas you already highlighted in step 6. Do not cover up any of the negative space you've already created.

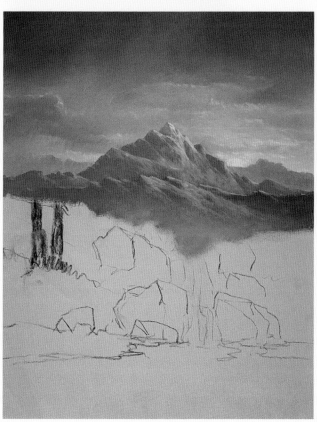

8. Apply Mist at Base of Mountains

Create a mixture of white + a touch of Ultramarine Blue + a touch of Dioxazine Purple. This should be a nice, soft, bluish purple color definitely on the blue side. Load a small amount on a no. 4 bristle and begin scrubbing in this color, using a very tight, circular motion. Scrub your way up and then scrub your way down, creating a soft mist.

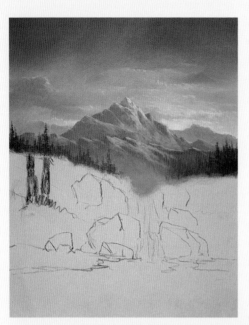

9. Paint Distant Pine Trees

Create a mixture of one part Hooker's Green + about one-fourth part Dioxazine Purple + about one-fourth part white. This value needs to be about three values darker than the value used on the mountains. Use either a no. 4 flat sable or no. 4 bristle to paint in the distant pine trees. Be careful not to make them too detailed; they should be only suggestive in form.

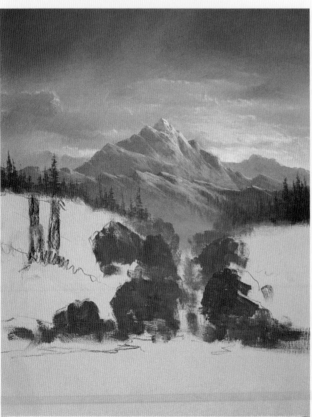

10. Underpaint Rock Formations

This is always a fun step. Instead of creating a specific color mixture, you will mottle several colors on the canvas to underpaint the rock formations. With a no. 4 or no. 6 bristle, and using most of the darker values (Ultramarine Blue, Burnt Sienna, Dioxazine Purple, Burnt Umber, etc.), begin mottling these colors in the areas where the rocks go.

As you're mottling, add touches of white to the rocks to create three values. These values will be used as follows: The back rocks will be the lightest value; the middle rocks will be the medium value; and the foreground rocks will be the darkest value.

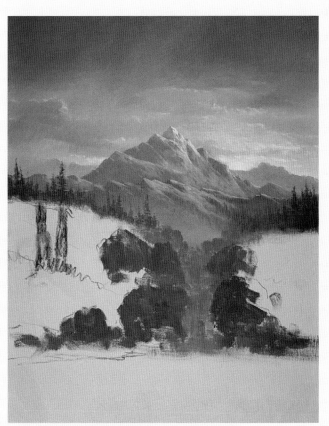

11. Underpaint Waterfall

Mix white + a touch of Ultramarine Blue + a touch of Dioxazine Purple. This particular color should be a little darker and a bit more on the purple side than the mist you painted in step 8. Use a no. 4 or no. 6 bristle to underpaint the water. Cover the canvas very well, as well as the edges of all the rocks.

12. Highlight Rock Formation

Mix white + a touch of Cadmium Orange + a little bit of Ultramarine Blue. Remember, blue is the complement to orange, so we use it here to gray the orange. Make the mixture very creamy and load a small amount on a no. 4 bristle. Keep in mind the light source is from the back-right side, so when you highlight, do so on the top-right side of each of the rocks. You can increase the brightness of this highlight later, so be careful not to overhighlight. Be sure your rocks have very good shapes, each unique from the others.

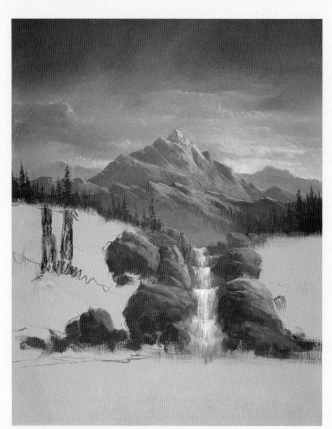

13. Highlight Waterfall

First, create a mixture of white + a touch of Cadmium Orange to create a tint. This should still appear white, so if your mixture has too much orange, make sure the white is dominant in the mixture. Make the tint very creamy and then load a small amount on the very tip or chisel edge of a no. 4 bristle. Then, holding your brush horizontal to the canvas and pointed straight at it, start at the top of the waterfall and pull downward with a very light, dry-brush stroke. Use this process lightly all the way down as you do each section of the waterfall.

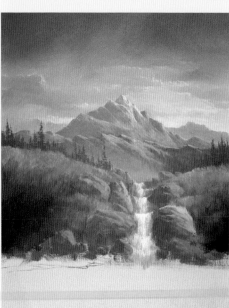

14. Underpaint Meadow

Starting at the base of the meadow, use a no. 10 bristle and mottle on Hooker's Green with touches of Burnt Sienna and Dioxazine Purple. Apply the paint fairly thickly. As you go upward toward the top of the meadow, begin adding touches of Phthalo Yellow-Green, Cadmium Yellow Light and Cadmium Orange.

While everything is still wet, take your brush and, beginning at the top of the meadow, push the grass upward, working your way down to the darker areas. This will create a grasslike texture. The paint needs to be applied fairly thickly in order for this technique to work properly.

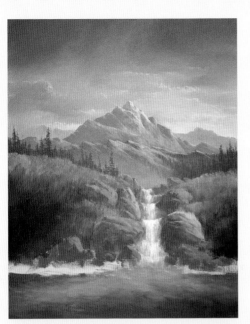

15. Underpaint Water

Mix one part Ultramarine Blue + one-fourth part Hooker's Green + about one-eighth part Dioxazine Purple. Load a no. 6 bristle fairly heavily. Starting at the bottom of the canvas, begin applying this color using short, choppy, horizontal strokes. As you move up toward the waterfall, begin adding touches of white to create various value changes until you have achieved approximately three value changes from light to dark. However, notice that the area along the shoreline is darker.

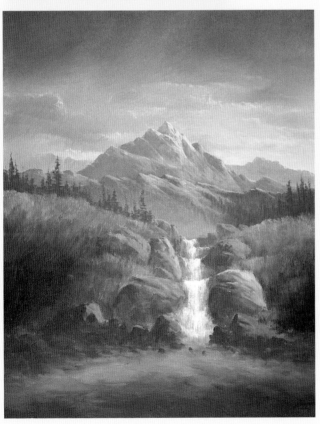

16. Underpaint Water's Edge

Mottle some dark colors as you did when underpainting the rocks in the waterfall. With a no. 4 or no. 6 bristle, take Burnt Sienna + touches of Ultramarine Blue and Dioxazine Purple. Scumble these colors along the shoreline and up toward the grass. You may want to add touches of white to create some miscellaneous value changes. This area will eventually become rocks, so it's OK if you leave a lot of brushstrokes and even more texture.

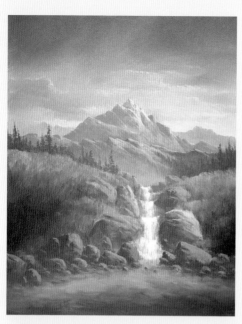

17. Highlight Water's Edge

Use the original rock highlighting mixture of white + a touch of Cadmium Orange and a little Ultramarine Blue, which will gray the color so it will be a little softer. Load a small amount on a no. 4 bristle; you can also use your no. 4 flat sable. Begin highlighting the smaller rocks and pebbles along the shoreline. Once again, be careful not to overhighlight. We will apply the final highlights later.

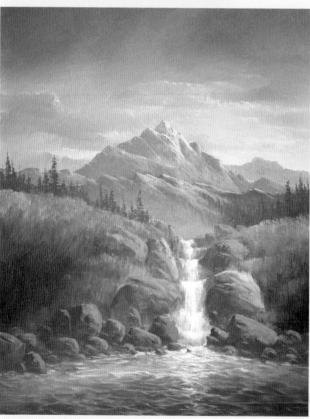

18. Ripple and Highlight Water

Create a water highlight color of white + a slight touch of Ultramarine Blue + a slight touch of Hooker's Green. This is only a tint, so don't add too much color. Make the mixture nice and creamy and load it fairly heavily on a no. 4 round sable. Starting at the base of the waterfall, begin highlighting the water by using short, choppy, horizontal strokes, creating numerous, interesting pockets of negative space. It's important to reload your brush very often to make sure the highlight color stays nice and bright.

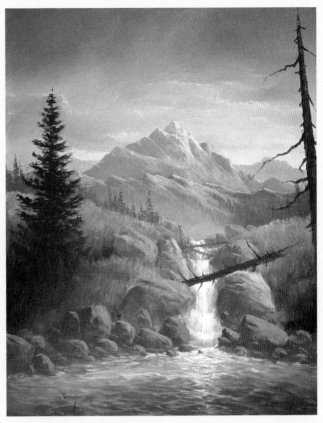

19. Underpaint Large Pine Tree

Mix one part Hooker's Green + one-fourth part Dioxazine Purple + one-fourth part Burnt Sienna. This should be a very dark, deep forest-green color. Before you start painting, you may want to take your soft vine charcoal or your white Conté pencil and draw a rough sketch of the basic shape. Then heavily load a no. 4 or no. 6 bristle with the tree mix. Turn the brush horizontally to the canvas, and, beginning at the center of the tree, start dabbing on this color, working your way outward and upward. This will gradually create the shape of the tree. It's important that you put the paint on fairly thickly so the tree has a little texture.

20. Underpaint Dead Pine Trees

Mix one part Burnt Sienna + one-fourth part Ultramarine Blue + just a slight touch of white to create a nice medium-to-dark brownish gray. Use a no. 4 flat sable to paint in the large dead tree on the right side. Then paint in the closest fallen log.

When you finish these two items, change the value of the dead-tree mixture by about two or three shades and add the background fallen logs.

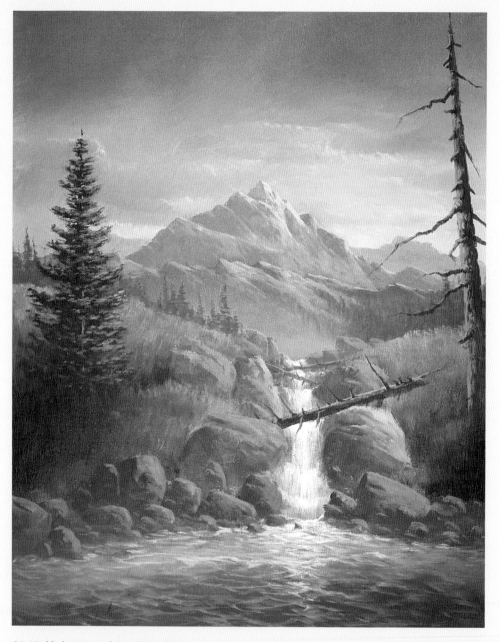

21. Highlight Live and Dead Pine Trees

To highlight the large live tree, mix Thalo Yellow-Green + a touch of Cadmium Orange + a touch of Hooker's Green. You can adjust this color to fit your own taste by adding more or less of any of the lighter colors. If you want more of a greenish highlight, add more green, a touch more yellow or even orange. Load the very tip of your no. 4 bristle and dab this color on the right side of the pine tree.

Mix the highlight color for the dead pine trees—white with a slight touch of Cadmium Orange and Burnt Sienna. Using short, choppy, vertical strokes with a no. 4 round sable, highlight the left sides of the dead trees. Then highlight the topsides of the fallen logs.

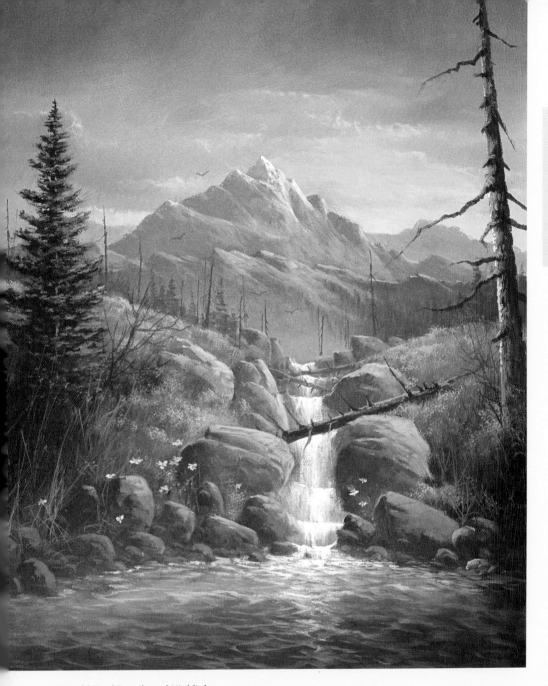

22. Add Final Details and Highlights

With the exception of adding a few flowers, this step is mostly about using your artistic license to highlight and add a few details such as tall weeds and tree limbs.

Create a couple very light-colored inky mixtures. Then take your no. 4 script liner and paint in some tall weeds.

Make a dark, inky mixture of one part Burnt Sienna + one-fourth part Ultramarine Blue. Use this mixture to paint in the tree limbs and any dead bushes you like. Then, with a little pure color (Cadmium Red Light, Cadmium Orange, Cadmium Yellow Light), take your no. 6 bristle and dab on a few miscellaneous wildflowers.

After you're satisfied with all the details you wanted to add, rehighlight any areas you feel need to be brighter.

Index

NORTH LIGHT BOOKS

An imprint of Penguin Random House LLC
penguinrandomhouse.com

ISBN 978-1-4403-2158-0

Printed in China
20 19 18 17

Cover Designed by Wendy Dunning
Interior Designed by Brian Roeth

About the Author

Jerry Yarnell was born in Tulsa, Oklahoma, in 1953.
A recipient of two scholarships from the Philbrook
Museum of Art in Tulsa, Jerry has always had a great
passion for nature and has made it a major thematic
focus in his paintings. He has been rewarded for his
dedication with numerous awards, art shows and gal-
lery exhibits across the country. His awards include
the prestigious Easel Award from the Governor's
Classic Western Art Show in Albuquerque, New
Mexico, acceptance in the top one hundred artists
represented in the national Art for the Parks com-
petition, an exhibition of work in the Leigh Yawkey
Woodson Birds in Art show and participation in a
premier showing of work by Oil Painters of America
at the Prince Gallery in Chicago, Illinois.

Jerry has another unique talent that makes him
stand out from the ordinary: He has an intense desire
to share his painting ability with others. For years he
has held successful painting workshops and seminars
for hundreds of people. Jerry's love for teaching
also keeps him very busy holding workshops and
giving private lessons in his new Yarnell Studio and
School of Fine Art. Jerry is the author of nine books
on painting instruction, and his unique style can be
viewed on his popular PBS television series, *Jerry
Yarnell School of Fine Art*, airing worldwide.

Metric Conversion Chart

TO CONVERT	TO	MULTIPLY BY
Inches	Centimeters	2.54
Centimeters	Inches	0.4
Feet	Centimeters	30.5
Centimeters	Feet	0.03
Yards	Meters	0.9
Meters	Yards	1.1